Personal Geographies

Explorations in *Mixed-Media* Mapmaking

JILL K. BERRY

NORTH LIGHT BOOKS

CINCINNATI, OHIO

www.CreateMixedMedia.com

Contents

4 Introduction

6 What is a Map?

7 Questions for the Cosmic Cartographer

7 Things to Map

8 Nontraditional and Quirky Maps

10 Parts of a Map

12 Designing a Compass Rose

13 Designing a Cartouche

14 Supplies for the Journey

CHAPTER 1
16 *Mapping the Self*

18 Head Map

22 Variation: Street Map

26 Body Map

30 Hand Map

34 Variation: Carved Copper Hand Map

38 Heart Map

42 Variation: Computer Heart Map

44 Articulated Self-Portrait

CHAPTER 2
56 *Mapping Your Experience*

58 Pop-Up Memory Map

64 Your Artistic Journey

70 The Right Place at the Right Time

76 Collaborative Map

82 Narrative Map

CHAPTER 3
96 *Plans, Projections and Possibilities*

98 Fictional or Channeled Maps

102 Variation: Realm of the Sea Dragon

104 Unfolding Maze of the Future

110 Cartographic Reliquary

116 Utopian Topography

120 Postcard Journal

124 Flipping Trip

138 Acknowledgements

139 About the Author and Contributors

142 Resources

143 Index

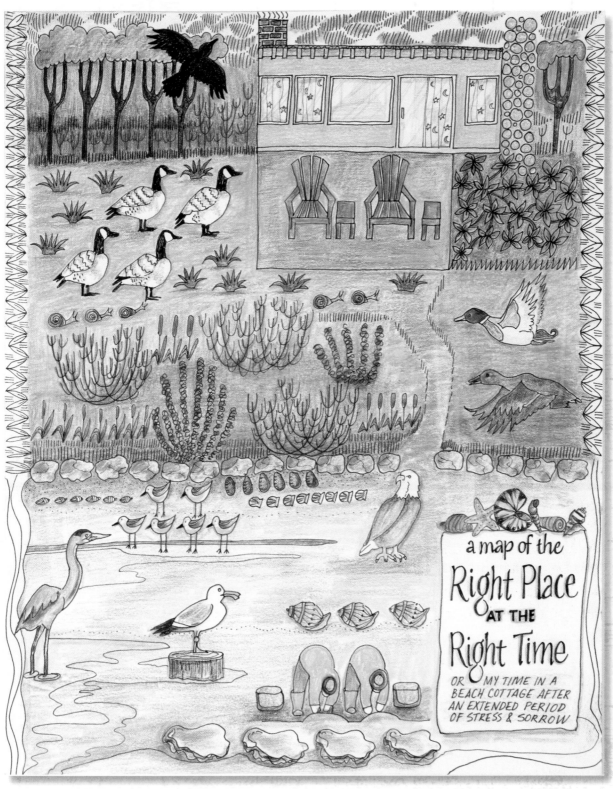

A Map of the Right Place at the Right Time
Jill K. Berry

Introduction

An Invitation to Explore

This book is a culmination of my love for stories, travel, design, mixed-media art, maps and history. It is also an invitation to you to explore yourself and the world of maps. No experience in cartography is necessary, just a willingness to join a long line of mapmakers who have shared an intensely rich legacy of stories and beautiful art.

Traveling and exploring are important both literally and metaphorically for me: I have a strong sense of the world at large and where I am in it. I grew up in California, lived in Hawaii and Italy, and now reside near the Rocky Mountains in Colorado. When I think of my dreams or hopes for the future or wonderful memories from the past, they often involve travel to exotic places. I belong to a heritage of curiosity: My grandparents and my mother traveled the world, and it was both my expectation and experience to do the same. I always come back from my travels with maps.

The word *cartophile* refers to those who have a strong attraction or addiction to maps. You may be one of them. I clearly fit this description. Historical maps, with their sinuous edges of the landscape, lapping lines of the shore, ships and sea monsters, make me swoon. New maps, from nontraditional to abstracted cartographic imagery, also appeal to me. Above all, I appreciate that a map allows me to point at one small place and know that "I am here." Maps make known our relationship to the world at large.

There are many, many books on maps and many artists that work in this genre. I wanted to not only look at maps, but employ the act of making them into my art as a tool for storytelling and self-discovery. After teaching a class on this subject for five years, I realized that anyone, regardless of experience, is able to do this with striking results. To that end, I purposely invited artists who had never made a map before to join me here as contributing artists, to see if it was an idea that would resonate with them. You can see that it did, in diverse, beautiful, funny, deep and enchanting ways. I have come to the conclusion that, with a small amount of prodding, each one of us can become an arty cartophile.

Who Out There is a Cartophile?

We are scientists, psychologists, government workers, writers, illustrators, bloggers, collectors, historians, movie-makers, intuitives and health workers. We are hoarders and art makers, library goers and Internet surfers. Our group is radically diverse in our interests, but what we all have in common goes beyond just the appreciation of legend, land and compass rose; it is curiosity.

When curiosity is set into action, when our wondering makes us want to wander off in search of something, the act of exploration is launched. When we set off into personal terrain, the possibilities are endless. Visually expressing these explorations of the mind, dreams and memories may easily result in maps.

Some cartophiles are attracted to the stories maps tell, some to their aesthetic and others to the knowledge a map can offer. Whatever we love about maps, history tells us that map lovers can become obsessive; they lie, cheat and steal to obtain maps, often to keep the maps for themselves rather than for financial gain. There are many stories throughout world history about map thieving, which still goes on today in the universities and libraries of the world. Making your own maps just may satisfy that itch and keep you on this side of the law!

Do Maps Always Represent the Facts?

Truthful cartography is nearly an oxymoron. Maps have always been subjective and reflective of a personal or cultural point of view. In the early centuries, Western maps were heavily influenced by religious beliefs. One powerful doctrine stated that there were four corners to the earth, and by decree, mapmakers made four-cornered maps for many years. In elementary school, I was told that brave Columbus sailed off to find the Indies on a flat world, facing the grave risk of sailing right off the edge. In fact, by the time Columbus sailed the ocean blue, scientists had known the world was round for at least two thousand years.

So, culture, religious zest and marketing efforts made by the explorers themselves resulted in maps that are more fantastic than factual. Sea monsters were added to show the bravado of the explorers, a marketing effort of sorts. It is as if they were saying, "We braved the high seas, discovered new lands, encountered fierce and ferocious creatures and lived to tell the tale! Invest your exploring dollars with us!"

False information from popular people stayed on maps for hundreds of years before being challenged, and if you were in the in-crowd, you may have had an island or country named after you, despite the fact that you did not discover it. Such was the case with Amerigo Vespucci, who arrived in America seventy-six years after China's and many other countries' explorers. But he was buddies with the latest go-to cartographer, so he got his name on the map. The history of cartography reads not a little bit like the history of your days in high school.

How This Book Works

We will explore making maps in three areas: maps of your physical self, maps of your experiences and dimensional projects with a cartographic theme. I was inspired by famous maps, poems, toys, experiences and quotes to create this diverse collection of projects. Sift through and find what appeals to you, and switch it up however you like—make it your own! In the end, you will have a personal atlas that is a visual memoir of your life.

Let us embark on the journey!

What Is a Map?

"A map has no vocabulary, no lexicon of precise meanings. It communicates in lines, hues, tones, coded symbols, and empty spaces, much like music. Nor does a map have its own voice. It is many-tongued, a chorus reciting centuries of accumulated knowledge in echoed chants. A map provides no answers. It only suggests where to look: Discover this, reexamine that, put one thing in relation to another, orient yourself, begin here . . . Sometimes a map speaks in terms of physical geography, but just as often it muses on the jagged terrain of the heart, the distant vistas of memory, or the fantastic landscapes of dreams."
—Miles Harvey, *The Island of Lost Maps*

"A map is a means of discovery, to be used for any kind of territory. It is a way to get from A to B, sometimes by way of Z. Most simply, a map is a cry from the wilderness, saying 'I am here!'"
—Katharine Harmon, author of *You Are Here* and *The Map as Art*

"We humans have been making maps since before we discovered writing, perhaps even before we mastered speech. Maps are our most primeval narrative instruments. They are fiction masquerading as non-fiction. We may decide to discover how truthful they are, or simply choose to enjoy their beauty. Some of the best stories I've ever read were maps."
—Frank Jacobs, author of *Strange Maps*

"Maps lessened the fear of the unknown and looked authoritative, even though there were blank spaces filled with animals, compasses, or cartouches, and some of the supposedly known areas were incorrectly drawn. Maps, however, opened up the imagination to faraway places while comfortably confirming what was known of the immediate surroundings. By making a diagram of something, you are confronting, even if you don't fully understand it."
—Nigel Holmes, *Pictorial Maps*

"Maps ultimately testify to our belief in the value of exploration, whether the compass is pointed inward or out. To do so is to appreciate the value of the mind as a dynamic vessel of exploration; it does not travel according to the limits of the compass rose, but moves by association. And when the mind comes to rest, when it ceases its orientating leaps and shunts and associations, we find ourselves back where we started, where Here intersects Now."
—Stephen S. Hall, "I, Mercator"

"The earliest extant alphabetic texts, the earliest extant geographical maps, and the earliest extant map of the human brain date back to the same general period: around 3,000 B.C. While no one can say for certain when the first writing and mapping occurred, the reasons for recording who we are, where we are, what is, and what might be haven't changed much over time. The earliest maps are thought to have been created to help people find their way and to reduce their fear of the unknown. We want to know the location of what we deem life-sustaining (hunting grounds and sources of fresh water, then; now, utility lines and grocery stores) and life-threatening (another people's lands; the toxic run off from a landfill). Now as then, we record great conflicts and meaningful discoveries. We organize information on maps in order to see our knowledge in a new way. As a result, maps suggest explanations; and while explanations reassure us, they also inspire us to ask more questions, consider other possibilities.

To ask for a map is to say, 'Tell me a story.'"
—Peter Turchi, *Maps of the Imagination: The Writer as Cartographer*

Questions for the Cosmic Cartographer

Before you start on your maps, peruse the adjacent list to define your map. These questions can help you decide the parameters of your cartographic project, the size and shape of your map, and what traditional elements you may or may not want to use.

- What is the territory, moment, story or journey of my map?
- Is the place lost or found, real or imagined?
- Is there an X on my map? What does it mean?
- What is the orientation of my map? East, toward Paradise? North, toward the Pole? South, because I am from Mississippi?
- What is the purpose of my map? To share, relive, explore or record?
- Who does the map serve? Me? A specific group?
- Are there dangers? What are they and where do they appear?
- Should I include longitude and latitude, or other lines of division? What will they stand for?
- What is the time frame of the map?
- What is the mood of my map?

Things to Map

You can make a map of nearly any journey, place, day or experience, however menial it might seem. Maps can be intimate and personal, or grand and inclusive. They can be a ritual way to journal your day, or a permanent and elaborate illustration of your life's journey.

A map is simply a visual record of meanderings, both mental and physical. Here are some ideas for things you could consider mapping.

- a day with your child
- a dog's life
- a fishing river
- a garden
- a grocery store
- a memory
- an island you would like to own
- a point of view
- a restaurant
- a school
- a soap opera
- a special place
- a story you are reading
- a wild place
- an idea
- a ski run or running trail
- how you got here
- your activities
- your childhood
- your community
- your day
- your future
- your heart
- your home
- your hometown
- your life history
- your vacation

"Twenty years from now, you will be more disappointed by the things that you didn't do than by the ones you did do. So throw off the bowlines. Sail away from the safe harbor. Catch the trade winds in your sails. Explore. Dream. Discover."
—Mark Twain

Nontraditional and Quirky Maps

Throughout history, artists and cartographers have made maps that are literal, metaphorical and abstract, and of every material imaginable: bone, rocks, paint, clothes, you name it. Here are just a few of thousands of quirky maps that may inspire you to unique cartographic expression.

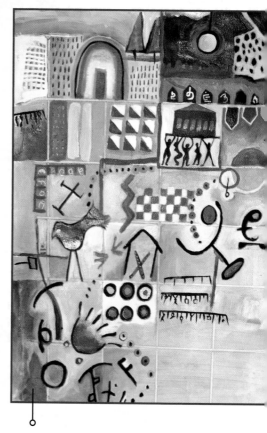

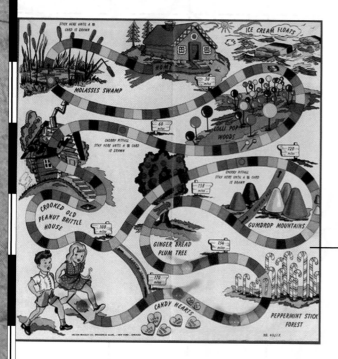

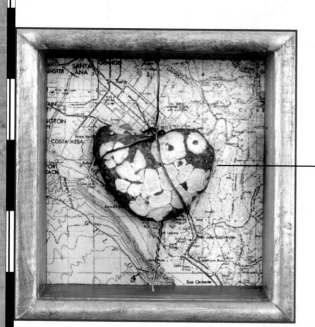

ABSTRACT MAP

This type of map takes a second look. I painted this map, inspired by the work of African artist Wosene Worke Kosrof. It is a wandering map of symbols that represent the whole of my day as a mother, from dawn until dusk.

BOARD GAME

You can *win* on this map. There is a path to the goal. You may encounter fortune, downfall, setbacks and just plain luck. Your riches will come and go, in the form of armies, money or real estate. You may be a little plastic traveler with no arms, a pewter car or shoe, or a cute cardboard cutout. This is not a map for a solo traveler; you are not alone.

FOUND OBJECT MAP

This type of map incorporates a natural or unnatural element that, without adornment, looks like a map. This one is a heart-shaped beach rock, with the residue of coral inhabitants making the map. It is superimposed over a map of where I found it.

INUIT COASTAL MAP

The Inuits carved three-dimensional coastline maps into nearly weatherproof wood as far back as three hundred years ago. The coastline was carved down one side of the wood, and up the other.

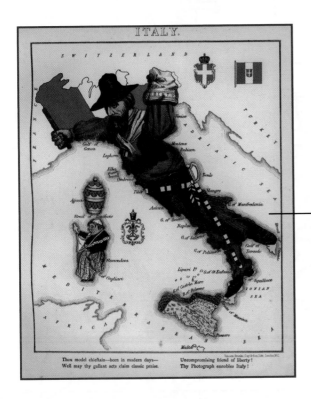

POLITICAL MAP

This is a map that shows lines defining countries, states or territories. In this case, Italy is depicted as a man about to kick the Pope, who is positioned as the island of Corsica. This map is a double metaphor: man as map, and politics as art.

PROSAIC MAP

This is a written description of a place, shaped as that place. I made this one of Africa, comprised of the text from Nelson Mandela's May 10, 1994 inaugural address.

Today, all of us do, by our presence here, and by our celebrations in other parts of our country and the world, confer glory and hope to newborn liberty. Out of the experience of an extraordinary human disaster that lasted too long, must be born a society of which all humanity will be proud. Our daily deeds as ordinary South Africans must produce an actual South African reality that will reinforce humanity's belief in justice, strengthen its confidence in the nobility of the human soul and sustain all our hopes for a glorious life for all. All this we owe both to ourselves and to the peoples of the world who are so well represented here today. To my compatriots, I have no hesitation in saying that each one of us is as intimately attached to the soil of this beautiful country as are the famous jacaranda trees of Pretoria and the mimosa trees of the bushveld. Each time one of us touches the soil of this land, we feel a sense of personal renewal. The national mood changes as the seasons change. We are moved by a sense of joy and exhilaration when the grass turns green and the flowers bloom. That spiritual and physical oneness we all share with this common homeland explains the depth of the pain we all carried in our hearts as we saw our country tear itself apart in a terrible conflict, and as we saw it spurned, outlawed and isolated by the peoples of the world, precisely because it has become the universal base of the pernicious ideology and practice of racism and racial oppression. We, the people of South Africa, feel fulfilled that humanity has taken us back into its bosom, that we, who were outlaws not so long ago, have today been given the rare privilege to be host to the nations of the world on our own soil. We thank all our distinguished international guests for having come to take possession with the people of our country of what is, after all, a common victory for justice, for peace, for human dignity. We trust that you will continue to stand by us as we tackle the challenges of building peace, prosperity, non-sexism, non-racialism and democracy. We deeply appreciate the role that the masses of our people and their political mass democratic, religious, women, youth, business, traditional and other leaders have played to bring about this conclusion. Not least among them is my Second Deputy President, the Honourable F.W. de Klerk. We would also like to pay tribute to our security forces, in all their ranks, for the distinguished role they have played in securing out first democratic elections and the transition to democracy, from blood-thirsty forces which still refuse to see the light. The time for the healing of the wounds has come. The moment to bridge the chasms that divide us has come. The time to build is upon us. We have, at last, achieved our political emancipation. We pledge ourselves to liberate all our people from the continuing bondage of poverty, deprivation, suffering, gender and other discrimination. We succeeded to take our last steps to freedom in conditions of relative peace. We commit ourselves to the construction of a complete, just and lasting peace. We have triumphed in the effort to implant hope in the breasts of the millions of our people. We enter into a covenant that we shall build the society in which all South Africans, both black and white, will be able to walk tall, without any fear in their hearts, assured of their inalienable right to human dignity - a rainbow nation at peace with itself and the world. As a token of its commitment to the renewal of our country, the new Interim Government of National Unity will, as a matter of urgency, address the issue of amnesty for various categories of our people who are currently serving terms of imprisonment. We dedicate this day to all the heroes and heroines in this country and the rest of the world who sacrificed in many ways and surrendered their lives so that we could be free. Their dreams have become reality. Freedom is their reward. We are both humbled and elevated by the honour and privilege that you, the people of South Africa, have bestowed on us, as the first President of a united, democratic, non racial and non sexist South Africa, to lead our country out of the valley of darkness We understand it still that there is no easy road to freedom. We know it well that none of us acting alone can achieve success. We must therefore act together as a united people, for national reconciliation, for nation building, for the birth of a new world. Let there be for all. Let there be peace for all. Let there be work, bread, water and salt for all. Let each know that for each the body, the mind and the soul have been freed to fulfil themselves. Never, never and never again shall it be that this beautiful land will again experience the oppression of one by another and suffer the indignity of being the skunk of the world. Let freedom reign. The sun shall never set on so glorious a human achievement!

God bless Africa!

CARTOUCHE
An ornamental frame on a map that is self-contained. It often has a scroll-like, oval shape and may be festooned with drapery, royalty, fancy folks, flowers, birds and nearly every other over-the-top decoration. It often displays the name of the map or mapmaker.

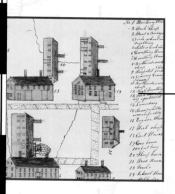

COMPASS ROSE
The compass rose has appeared on charts and maps since the fourteenth century. The term "rose" comes from the figure's compass points resembling the petals of a rose. Originally, this device was used to indicate the directions of the winds and was divided into thirty-two points; at this time it was called a "wind rose." Nowadays, it is used to indicate the cardinal directions: North, South, East and West.

CREATURES
These include natives, sphinxes, sirens, harpies, religious figures, sea monsters and humans, in the water or out.

LEGEND
Also called a map key, a legend is an explanatory table of symbols on a map. Note that map symbols in your country are often used for different things in other countries. For example, the symbol for a secondary highway on a United States Geoglogical Survey topographic map is equivalent to a railroad in Switzerland.

NEATLINES
These are the borders of a map, often double or dashed lines. They help to define the edge of the map area and let you know that you have the whole map. And, they keep the map in a neat box.

LONGITUDE AND LATITUDE
These combine to make the grid system that helps pinpoint places on the earth. Lines of latitude are horizontal and often referred to as parallels, as they are equidistant from each other. Lines of longitude are vertical and are often referred to as meridians. These lines are closer together at the poles, and widest apart at the equator.

PATHS AND PLACES
These are cities, states, ideas, zones, sections, blocks, areas, segments, circuits, kingdoms and dominions with streets, roads, highways and trails. Have you ever wondered who gets to name all these? In this case, it is you!

SCALE

The scale shows the relationship between distances on a map and the corresponding distances on the earth's surface. A large-scale map shows a small area with a large amount of detail. A small-scale map is a bird's-eye view: a large area with a small amount of detail.

TOPOGRAPHY

This includes the surface features of a place or region, indicating their relative positions and elevations.

TERRA INCOGNITA

Terra Incognita is a term used in exploration for "unknown territory," an area that has not been mapped or documented. A legend claims that cartographers labeled such regions with "here be dragons."

TRAP STREETS

A phony street set on a map, for the purpose of "trapping" potential copyright violators. If the street gets transferred, you know your map was copied. Fortunately, copying maps was not a historically punishable crime. It was simply the way of the mapmakers of the world, but was also the reason errors remained on maps. Because of copying, St. Brendan's Island, a nonexistent paradisiacal island, stayed on maps for over a thousand years. Guess we would have to call this one "Trap Island."

VOYAGING VEHICLES

These are ships, trains, wagon trains, cars, hot-air balloons, helicopters, magic carpets and any other conveying machine.

WATER FEATURES

These are oceans, seas, straits, sounds, rivers, lakes, ponds, tears, birdbaths, whirlpools and swimming pools.

WINDS AND WIND BLOWERS

There are four: Zephyrus, (most gentle and in charge of breeze) from the West; Boreas (nasty and vindictive) from the North; Notus (warm and moist storms) from the South; and Eurus (warm and rainy) from the East.

Designing a Compass Rose

A compass rose shows you the orientation of your map using points for each of the cardinal directions: North, South, East and West. It can also point you in other directions: to fame, fortune or notoriety. Just about anything can be used as a compass rose; there is no tradition or standard. The template below may be copied or traced and used to define the directions in your map.

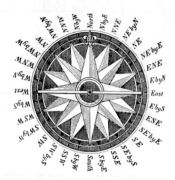

Historic clip art (see Resources on page 142)

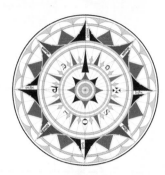

Historic reproduction

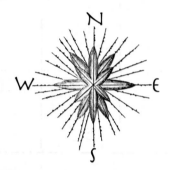

Scientific clip art with text added

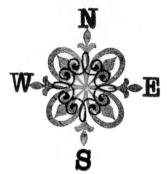

Rubber stamps

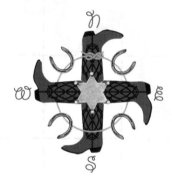

Digital collage of clip art

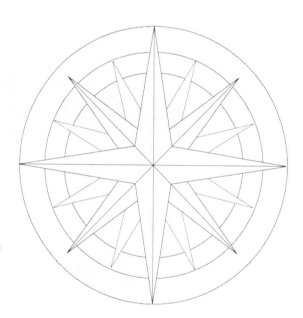

Vintage image with added text

Compass rose template

Designing a Cartouche

Cartouches are decorative frames that hold titles, scales and other information about a map. The Italians started the tradition in the sixteenth century, and the Flemings and the Danish got wilder with the idea in the seventeenth century. The rest of the world went along with these fancy ornamental elements until the ninteenth century. Cartouches are historically remarkable for their diversity, symbolism, social narrative and artistic beauty.

As you can see from the examples below, there are many ways to make a cartouche. This a good area on your map to go right over the top with your artistic license. There are also many resources to help you in the way of clip art, books and CDs (see Resources on page 142).

Collaged with paste, paper and charms

Clip art with computer type

Rubber stamp animals and cut paper
title with pochoir background

Map, paper tape, photo and stamped letters

Clip art with added text and color

Supplies for the Journey

I am all over the map in the projects in this book, so the list is long. But fear not—you may already have many of these supplies on hand. If not, use what you do have, or have a map party and share! Each project calls for additional supplies; these are just the basics.

Papers and Substrates

- binder's board or heavy cardboard
- clip art
- colored cardstock
- copier paper
- cover weight paper
- hot press (smooth) or cold press (bumpy) watercolor papers, 140 lb.–300 lb.
- maps of all kinds
- mat board
- Mylar for cutting stencils
- papier mâché substrates
- photographs
- postcards
- scrapbooking paper
- transparent vellum or tracing paper
- unryu paper

Drawing Tools

- colored pencils, including white
- graphite pencils, 2B–6B
- opaque crayons
- soft, kneaded and black erasers
- watercolor crayons
- waterproof black pens

Coloring Tools

- acrylic paints
- alcohol paints
- dye-ink pads
- gouache paint
- iridescent watercolors
- PanPastels
- watercolors

Trims and Embellishments

- beaded trim
- charms, milagros and recycled jewelry parts
- map tacks
- rayon floss
- ribbons: dashed, translucent, floral, metallic or striped

Metal-Working Tools

- copper foil
- craft wire—16-gauge or thicker
- liver of sulphur
- metal brads
- steel wool

Adhesives

- glue stick
- PVA (polyvinyl acetate)
- soft gel matte medium
- semi-gloss gel medium
- double-sided tape
- low-tack painters' tape

Miscellaneous Tools

- awl
- bone folder
- cosmetic sponges
- craft knife or scalpel
- cutting mat
- Japanese screw punch
- paper hole punch
- scissors
- straightedge
- stencil brushes
- stylus

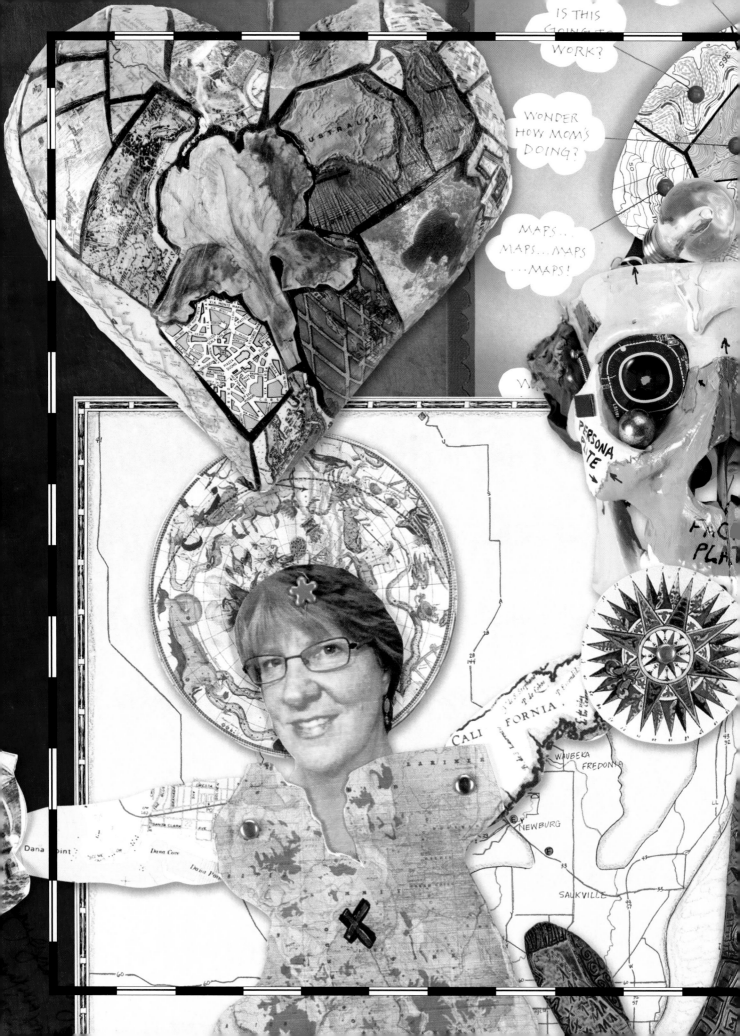

CHAPTER 1
Mapping the Self

Maps of the self are steeped in tradition and can be traced back as far as ancient Greece. However, they have not been a part of our Western culture until perhaps right here and now. When creating a map of the self, you are facing the most familiar territory (yourself) and the least familiar (also yourself). Along the way, you might discover some facts about yourself that surprise you. Isn't it true that the more you learn, the more you realize what you don't know? At no time is this truer than in the exploration of our own selves.

This chapter is a baby start to finding out what has gone on, stuck like glue, pin-pricked or otherwise affected you. You will explore your head, without having to pay a Jungian analyst; your body, without a physical therapist; your hand, without a palm reader; and your heart, without a cardiologist. Finally, you'll fashion yourself as a fun, swiveling, cartographic play toy.

All of these maps end up being beautiful, regardless of the mapmaker's level of artistic experience.

The process and results are for personal enrichment and aren't necessarily pieces you will want to sell, give to a relative or even hang on a wall. They are stretching exercises—artistic yoga—to help sort out and celebrate the maze that is inside of you and to introduce the art of mapmaking as a tool of self-discovery.

This kind of exploration is nearly free, and it is fun. You get to use crayons if you like, and I recommend that you do. And whatever state you find yourself in—contentment, discomfort, hilarity or sadness—learning and creating will make it better.

You will discover your inner terrain by completing exercises that have to do with your own physical experience. Dive into yourself and wander around to see what you find. Are you bumping into cynicism and fear, or are the gardens of possibility blooming? What makes your heart sing and your hands clap? And which people, places and events contributed to the enchanted land that is you?

Enter into the map of yourself. . . .

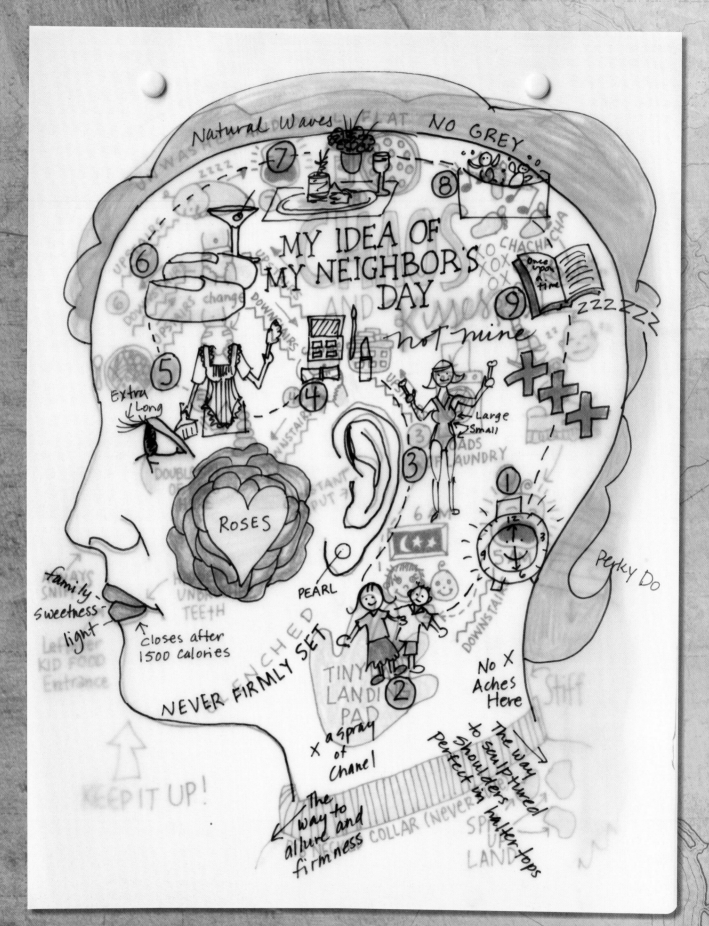

Head Map

Before you begin this project, isolate an idea that is predominant inside your head, and then determine the opposite of this idea. You will create two overlaid maps using these ideas. The maps are overlaid because the combination creates the whole picture. Make up your own mind and map your head!

My Map Story

The predominant idea of my head map is "My Idea of My Neighbor's Day," the opposite of which is "My Day." I was forty-one when both of my kids were born, and being a stay-at-home mom was a huge adjustment from having a demanding career. Each day, I would walk my kids to school and gather with the other moms to watch them walk through the doors. It seemed to me that every mom, with the exception of me, was fit, groomed to perfection, cheerful, happily married and devoid of stress. Some of them had more kids than I did, and they balanced all of it with a smile on their faces and size six jeans.

I, on the other hand, was harried, always tired, running up and down the stairs all day and never well-dressed. At one point, this situation depressed me, but after creating the map and seeing how ridiculous it all was, I had to laugh. It was likely that the other moms felt far closer to how I did than I ever suspected.

Not all head maps are as lighthearted. When I teach this class, I listen to my students' conversations as they discuss their predominant ideas and figure out their opposites. As I listen, I make a map of the their conversations called "Class Head." In one class, my ears perked up when one student whispered, "What is the opposite of cancer?" The answer, we decided, was the rest of her journey that did not include cancer.

MATERIALS AND TOOLS

1—8½" × 11" (21.5cm × 28cm) piece of cover weight paper

2—8½" × 11" (21.5cm × 28cm) pieces of vellum

2 brads

black fine-tip permanent marker

head template (see page 21)

opaque crayons

paper hole punch

SYMBOLICAL HEAD
ILLUSTRATING THE
NATURAL LANGUAGE OF THE
FACULTIES.

Inspired by . . .
Phrenology Chart

Head maps were used in phrenology, a nineteenth-century pseudoscience primarily based on the concept that personality characteristics are organized in the brain in sections. It was thought that the size of each section would shrink or grow depending upon the usage of its contents. Phrenologists believed you could decipher a person's personality by the shapes and bumps on his or her head. The template on page 21 is inspired by the sectioning tradition of phrenology and provides a jumping-off point to analyze the contents in your head.

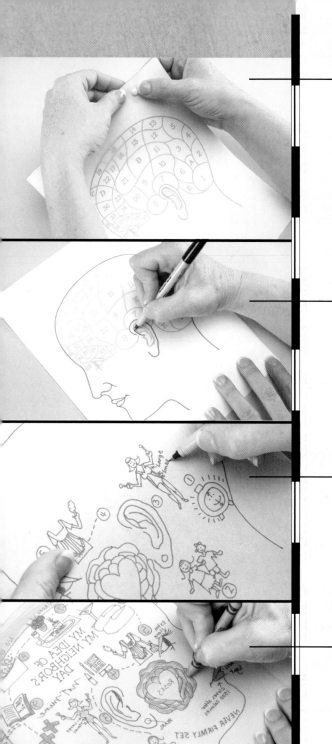

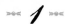 **1**

Place the head template (see next page) on top of a piece of cover weight paper and two sheets of vellum on top of the template. Punch two holes in the tops of all four sheets at once. Remove one piece of vellum and set it aside. Fasten brads through the holes to hold the sheets together and keep them from sliding around as you work.

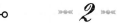 **2**

Trace the head template onto the vellum using a black fine-tip permanent marker. Trace the grid if you desire.

3

With a fine-tip permanent marker, draw symbols that represent your predominant thought. Remove the brads and the map you just finished.

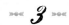 **4**

Turn the vellum over and color the symbols on the back of the vellum with opaque crayons. This creates a soft color under the sharp black of the pen and adds a playful element.

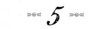 **5**

Attach the blank sheet of vellum to the template and backing paper using the brads. Repeat Steps 1–4 to create a head map, this time using the opposite idea. Reattach all the pieces: the predominant idea on top, the opposite idea in the middle and the cover weight paper on the bottom.

HEAD TEMPLATE
Actual Size

Last year, my friend had a stroke and temporarily lost her speech and power of movement. I felt helpless after seeing her, and when I came home, I made this map. I knew that despite the darkness around her, the inside of her head was still full of wonder.

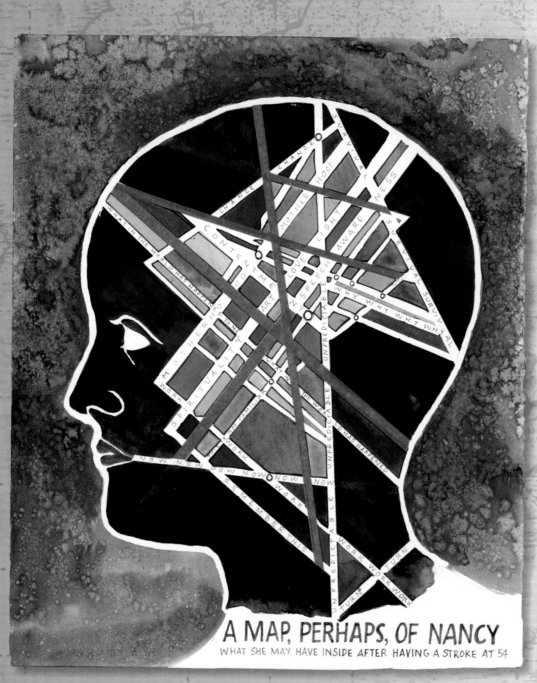

MATERIALS AND TOOLS

1—9¼" × 11" (23.5cm × 28cm) piece of watercolor paper

4B–8B pencil

black fine-tip permanent marker

craft knife

cutting mat

eraser

fine-tip paintbrush

hard pencil

head template (see page 21)

iridescent or regular watercolors

low-tack painters' tape

masking pen

Note: You can also use liquid frisket or another removable resist, applied with a fine-tip paintbrush.

sea salt

straightedge

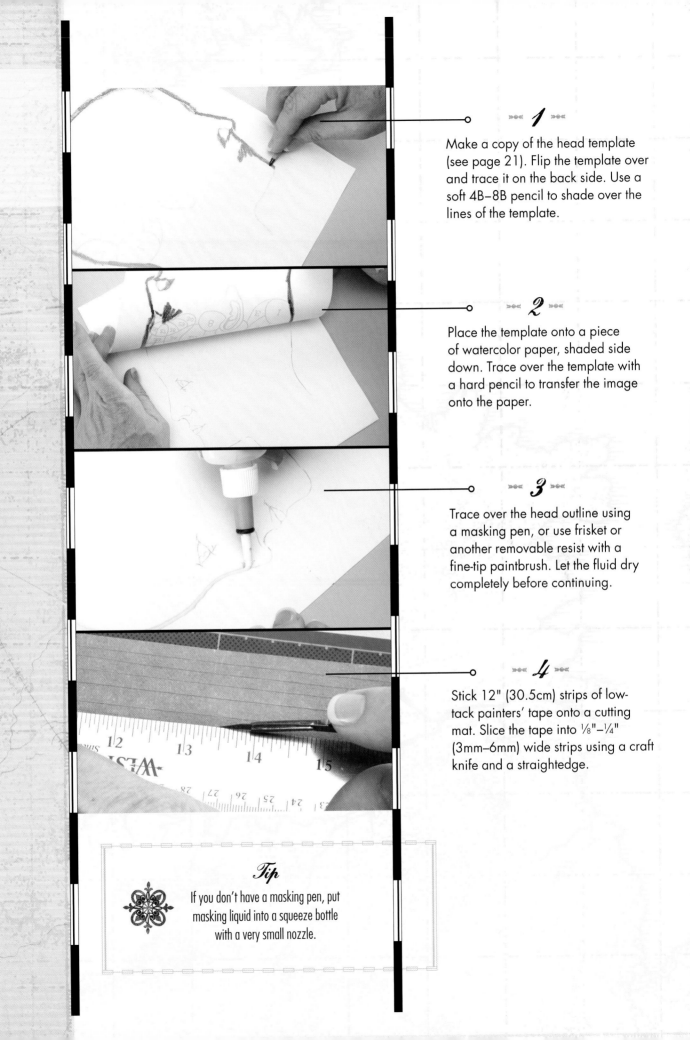

1

Make a copy of the head template (see page 21). Flip the template over and trace it on the back side. Use a soft 4B–8B pencil to shade over the lines of the template.

2

Place the template onto a piece of watercolor paper, shaded side down. Trace over the template with a hard pencil to transfer the image onto the paper.

3

Trace over the head outline using a masking pen, or use frisket or another removable resist with a fine-tip paintbrush. Let the fluid dry completely before continuing.

4

Stick 12" (30.5cm) strips of low-tack painters' tape onto a cutting mat. Slice the tape into ⅛"–¼" (3mm–6mm) wide strips using a craft knife and a straightedge.

Tip
If you don't have a masking pen, put masking liquid into a squeeze bottle with a very small nozzle.

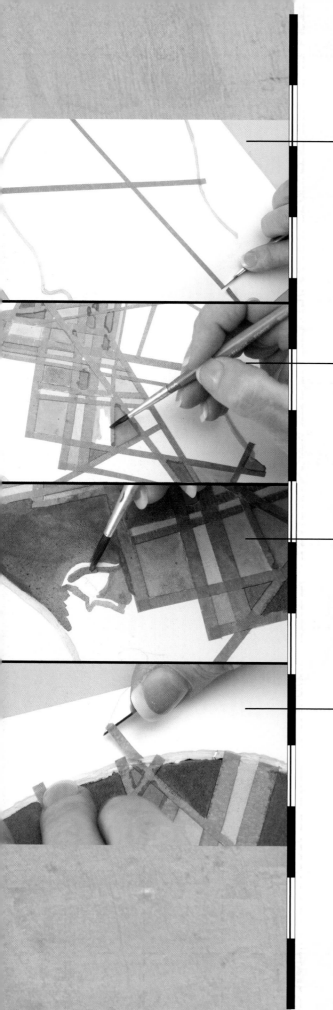

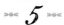

5

Position the tape strips over the head as desired. They can extend slightly over the masking fluid edges of the head shape. Trim each strip with the craft knife. Press the strips firmly to the paper to make sure the paint won't seep underneath them. Continue until you have created a neighborhood. The taped areas will be the streets.

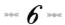

6

Paint inside the rectangles and shapes created by the masking tape strips using iridescent or regular watercolor paints and a fine-tip paintbrush.

7

Paint the surrounding areas of the head using contrasting tones and shades of watercolors. Leave a thin outline of white space around the eye, nose and mouth details.

8

Trim all the bits of tape that extend past the masking liquid border.

⋙ *9* ⋙

Draw the neck of the figure with a pencil; this will be the space for the title. Paint the background around the exterior of the head with watercolors. While the paint is still wet, sprinkle the background with sea salt. When the paint is dry, brush the salt off, leaving starburst shapes that add texture.

⋙ *10* ⋙

When the picture is completely dry, carefully remove the tape and masking liquid. Reapply some of the strips of tape to add depth. Erase the pencil lines.

⋙ *11* ⋙

Outline the streets and label them with a black fine-tip permanent marker. Add a title in the neck area.

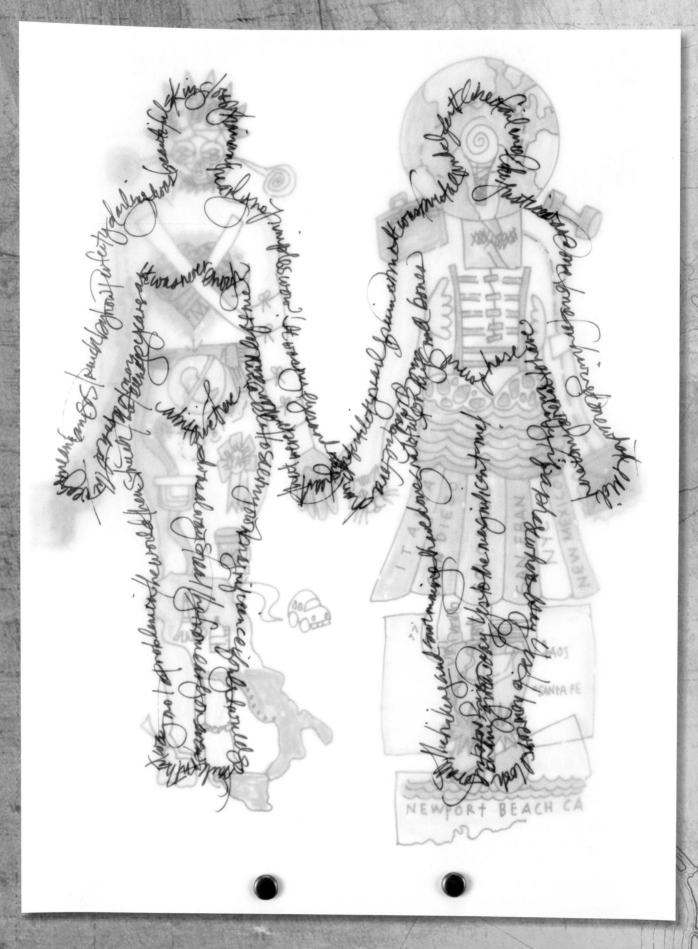

Body Map

No matter how long you have lived, your body has stories to tell. Scars, illnesses, childbirth, your stint on the track team or your three-month trek in Nepal that left you with shin splints—the things you've been up to all this time weave a map of stories from head to toe. A part of that terrain also includes what didn't happen: the vacancies, empty spaces and silhouettes of unrequited relationships or events.

In this exercise, you will make a two-layered map of your body. The first layer is symbolic (graphics, drawings and symbols), and the second layer is prosaic (words or journaling). The symbols used here are abstracted to represent your experiences. Working this way frees you to say what you like, and because you invent the symbols, no one else need know what they stand for. The point is not to make your map legible, but to think of the experiences of your physical self and record them in your own symbolic language.

MATERIALS AND TOOLS

1—8½" × 11" (21.5cm × 28cm) piece of cover weight paper

2—8½" × 11" (21.5cm × 28cm) sheets of vellum

2 brads

black fine-tip permanent marker

body template (see page 29)

opaque crayons

paper hole punch

Inspired by . . .
The Body Mapping Project

Art2Be is a group of Kenyan and European visual artists and therapists who use body mapping as a creative and therapeutic tool for people often left in the periphery of society for economical, social or health reasons. The body maps are used to allow children, youth and adults to tell their life stories, share their concerns and dreams with their families, and campaign for their rights.

My Map Story

My map has a ladder running up the back of the body, a symbol of striving and strength. The skirt is made of gores that represent cities, and the head is a globe, representing worldly thoughts. There are roads, reminder string ties, fractures, lightning bolts and light bulbs. All of these symbols have meaning to me, but I doubt if my map can be easily interpreted by anyone else.

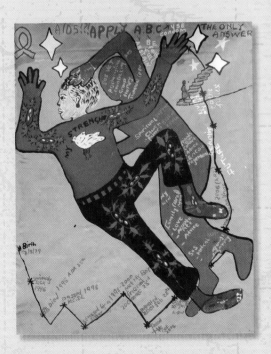

>⦁< *1* >⦁<

Place the body template (see next page) on top of an 8½" × 11" (21.5cm × 28cm) piece of cover weight paper. Place two 8½" × 11" (21.5cm × 28cm) sheets of vellum on top of the template. Punch two holes in the bottoms of all four sheets at once. Remove one piece of vellum and set it aside. Insert brads through the holes to hold the sheets together and keep them from sliding around as you work.

>⦁< *2* >⦁<

With a black fine-tip permanent marker, use the template as a guide and draw symbols that loosely mimic the shapes of the front and back of the body. Draw anything that reminds you of your body's experiences, using whatever designs or symbols that make sense to you. A heart with initials of loved ones, sparks radiating from injured areas or cracks signifying broken bones are just some examples.

>⦁< *3* >⦁<

Remove the brads and take apart the pages. Flip the sheet of vellum over and color your drawings with opaque crayons.

>⦁< *4* >⦁<

Using the brads, attach the blank piece of vellum to the template. Using the template as a guide, journal with a black fine-tip permanent marker around the body shapes so that the words form the shapes of the bodies. As you journal, think about the feelings you have had about your physical self. Are you healthy and strong, or challenged by weight or illness?

Reattach all the pieces: the prosaic bodies on top, the symbolic bodies in the middle and the cover weight paper on the bottom.

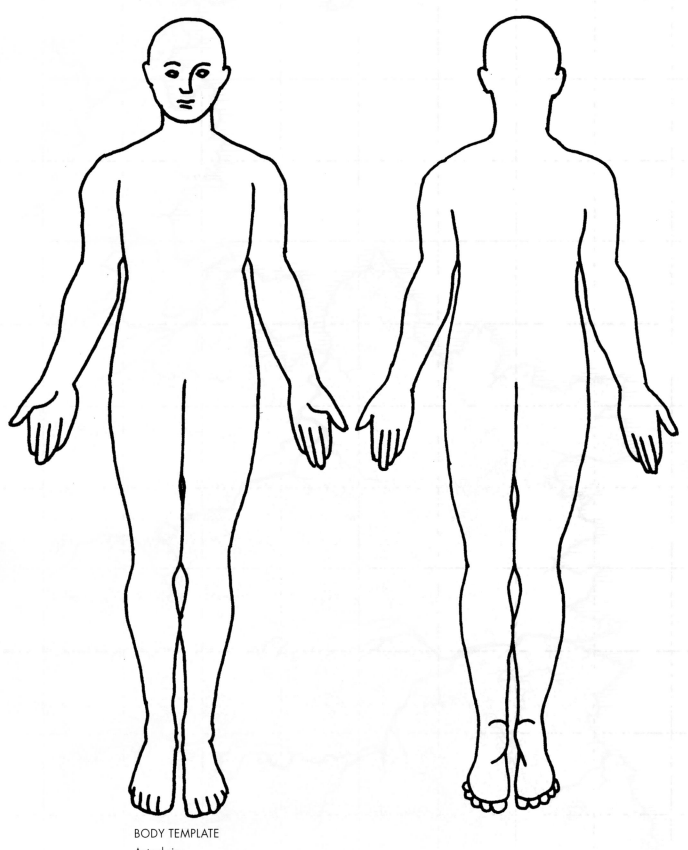

BODY TEMPLATE
Actual size

29

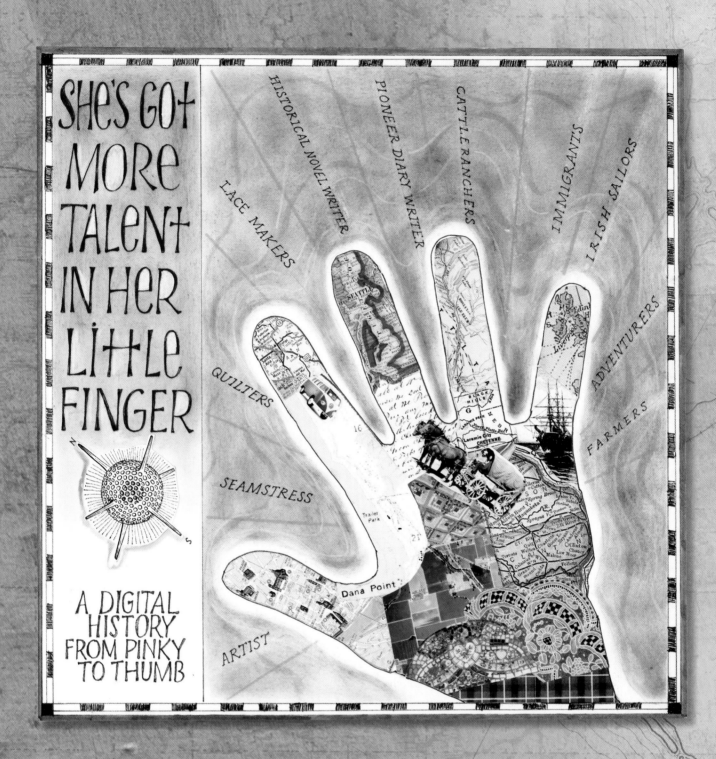

SHE'S GOT MORE TALENT IN HER LITTLE FINGER

A DIGITAL HISTORY FROM PINKY TO THUMB

LACE MAKERS
HISTORICAL NOVEL WRITER
PIONEER DIARY WRITER
CATTLE RANCHERS
IMMIGRANTS
IRISH SAILORS
ADVENTURERS
FARMERS
QUILTERS
SEAMSTRESS
ARTIST
Dana Point

Hand Map

The *Hand Map* is a collage of your hand, using imagery that symbolizes people or places that have contributed to what you do with your hands. It is also about who has held them along the way.

My Map Story

My aunt Mary was a hardworking ranch wife who had little time for play. She used to say that I had more talent in my little finger than she did in her whole hand. Though she died a number of years ago, I still picture her cheering me on and holding my hand. I wondered about the provenance of her proverb, but could not find its origin. So, I focused on the little finger part of it. Where did the talent in my little finger come from?

After a bit of research, I found out that some of my ancestors, three Irish brothers, traveled to America from Ireland on a ship in the 1840s. Two of the brothers stayed in the United States, became farmers in Ohio and married women who farmed, quilted and tatted lace. They had children, and the children moved by way of horse and wagon train to Wyoming, Washington and California. Along the way, the children wrote, carved leather, made mosaics, quilted and continued farming. One family settled in Washington, where my mother was born. My mother moved to California and drove us up and down the southern coast in a Volkswagen van. She also supported me when I went to Florence to do graduate work.

In my hand map, the Irish brothers are sailing into my little finger. The rest of the fingers are places where my family made homes. The palm is a collage of all the things they did with their hands, and the thumb is my graduate year in Florence. The compass rose is a drawing of a shell, because I have spent a lot of contemplative time on the beach.

MATERIALS AND TOOLS

1—11" × 11" (28cm × 28cm) piece of watercolor paper

black fine-tip permanent marker

clip-art compass rose image

colored pencils

dye ink pads

foam brush

gel matte medium

maps, photos and images that represent what you and your relatives did with their hands, and where your ancestors came from

marking pens

pencil

scissors

straightedge

stencil brush

sturdy paper

watercolors (optional)

white pen

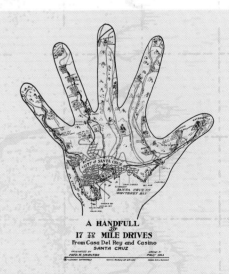

A HANDFULL
17 18 MILE DRIVES
From Casa Del Rey and Casino
SANTA CRUZ

Inspired by . . .
Vintage Hand Map

This map was published in 1912 and was a promotional effort on the part of a builder and civic leader of Santa Cruz. The lines of the map are reminiscent of the lines that are used in reflexology and palmistry, which are the oldest traditions of hand maps.

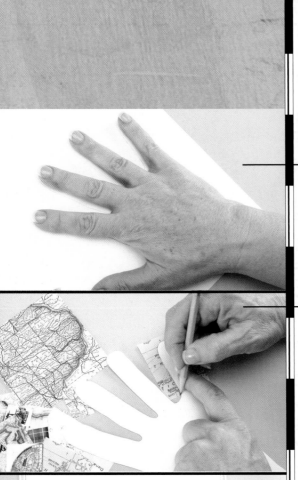

1

Make a hand template by tracing your hand on a piece of sturdy paper using a pencil. Cut the template out.

2

Gather small bits and pieces of maps, photos and other imagery that have to do with the history of your family or your own creativity. Use the hand template to cut out shapes from the maps that will fit within the hand like puzzle pieces. You can choose to use the contours of the maps to dictate where they will go on the hand. For example, the curve of the river in one map fit the roundness of the side of my palm. Content also dictates where a map will go. For example, the map of Ireland is the start of my journey, so that map went on my little finger.

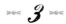

3

Draw neatlines around the edge of a piece of watercolor paper using a black fine-tip permanent marker and a straightedge. Use the hand template to trace the hand shape extending from the lower right corner.

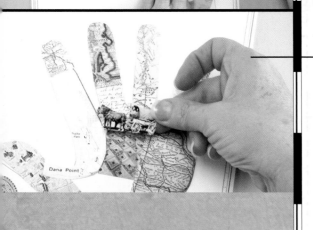

4

Collage the map pieces, fitting them together like a puzzle, over the hand shape. I placed the finger pieces first, since they are chronological in my map. Adjust the placement until there is no white space showing. Using gel matte medium and a foam brush, glue all the pieces to the hand.

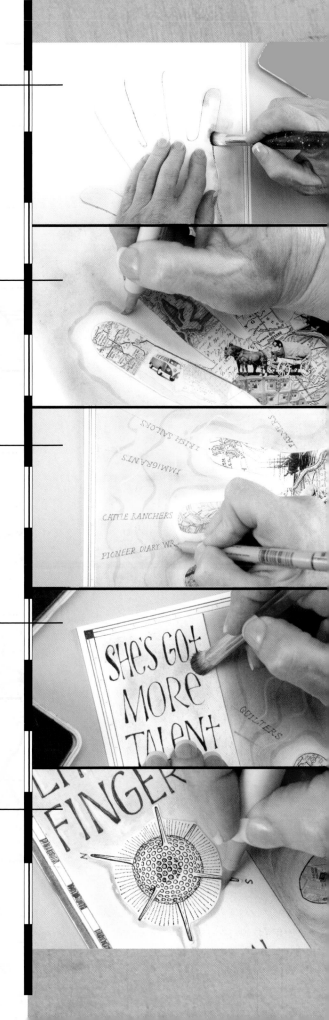

5

Place the hand template over the collaged hand. Apply dye ink to the background using a stencil brush. Leave a fourth of the map on the left side blank for the title block.

6

Add contour lines and shading with marking pens and colored pencils.

7

Using a black fine-tip permanent marker, add descriptions around the hand of what your ancestors did. Make light guidelines radiating from the center of the palm. Each description should radiate from a finger, and some descriptions can go in between.

8

Write the name of your map in the title block area, or print it out and glue it in the title block area. Apply dye ink or watercolors around the title. Highlight the insides of some of the letters using a white pen.

9

Cut out an image of a shell or another compass rose image and glue it below the title. Add a drop shadow around the compass rose with a marking pen to add depth.

VARIATION
Carved Copper Hand Map

I traced my mother's hand and interviewed her about the history of her creativity and her hand-holders. In the process, I learned a lot about my mom, the people she values in her life and all the places she holds dear.

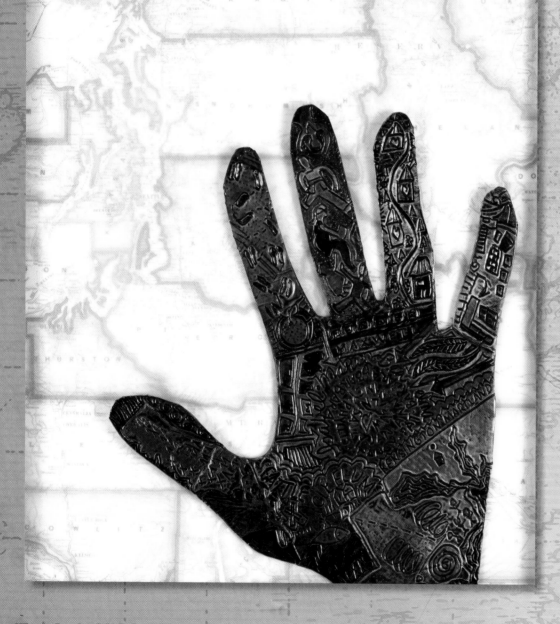

MATERIALS AND TOOLS

1—8" × 10" (20cm × 25cm) map

1—8" × 10" (20cm × 25cm) picture frame

1—8" × 10" (20cm × 25cm) sheet of vellum (optional)

1 piece of 300 lb. watercolor paper, large enough to accommodate a hand

alcohol inks

bone folder or other rounding tool

copper foil

cotton balls

fine-tip paintbrush

glue dots or double-sided tape

liver of sulfur

palette

pencil

rubbing alcohol

scissors

steel-wool pad

stylus

white glue

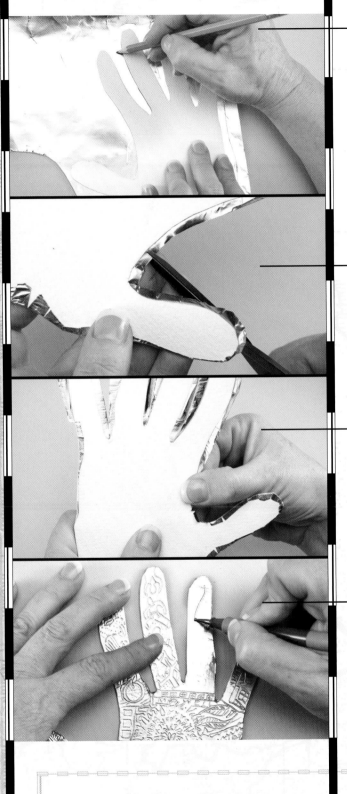

1

Trace the hand you want to map onto watercolor paper. Cut out the hand shape. Using a pencil, trace this hand onto copper foil, palm-side down, leaving a margin for wrapping the edges.

The copper will be placed on the top of the hand, so pay attention to the orientation. This example uses the right hand. If you are left-handed, your hand will project from the left side of the piece.

2

Cut the copper foil hand outline, keeping a consistent margin. Adhere it to the paper hand with a thin layer of white glue. Where the hand outline curves, snip the foil margin into smaller segments to make wrapping smoother.

3

Wrap the foil margin around the entire hand. Soften the curves of the fingers with a bone folder or other rounding tool, or by gently using your fingers.

4

Carve a design with a stylus, using a firm but gentle touch. You want to mark the copper without tearing it. Carve names, maps, places and other details that are significant to your subject.

Tip

When using the stylus on soft paper, it is easier to pull than to push the tool.

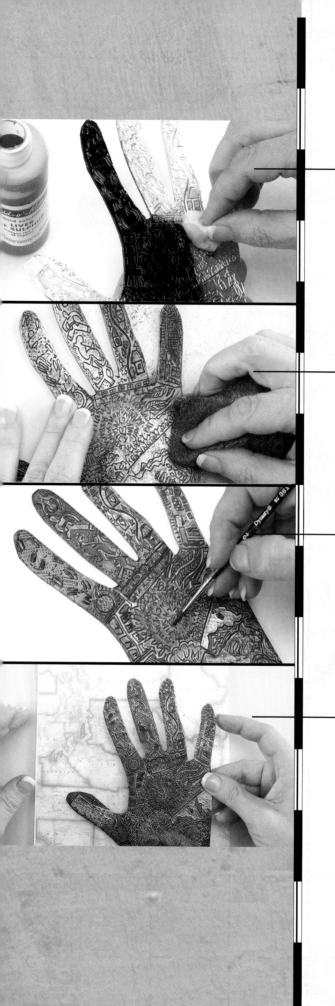

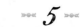
5

Apply liver of sulphur to the copper hand with a cotton ball until the hand is black. Don't neglect the outside edges. Let the hand dry.

6

Gently buff the liver of sulphur away with a steel-wool pad. The carved design will remain black.

7

Paint the copper hand with alcohol inks and a fine-tip paintbrush. You can thin the paint and clean the brushes with isopropyl alcohol. Let it dry.

8

Mount the hand on a map using glue dots or double-sided tape. You may choose to place a sheet of vellum over the map to soften the image and help the hand remain bold. Set the piece in a frame.

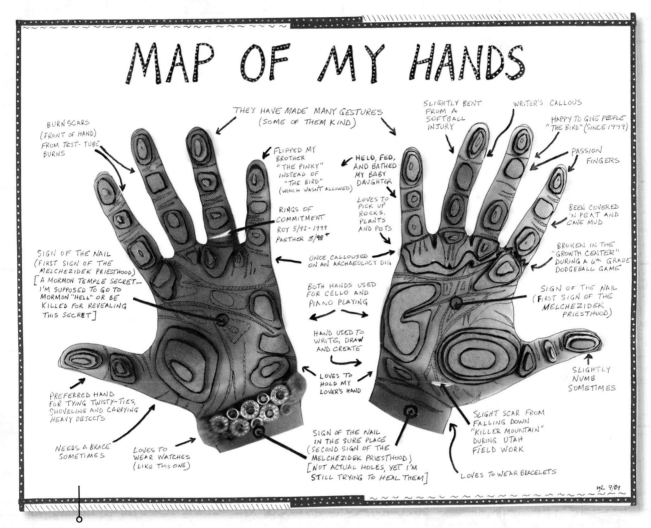

Map of My Hands

Heidi LaMoreaux

Map of My Hands explores some of the uses and misuses of my hands over the years, including scars, gestures, injuries and other features. The layers are loosely topographical, with the higher points in the landscape of my hands containing more layers of foam and the lower points being illustrated as depressions.

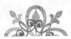

Heart Map

There have been times when my heart has felt something close to ecstasy, a surge of gratitude for the simple fact of being alive. Make a list of places you have been where you've felt like this: while cradling a newborn baby, traveling abroad or simply appreciating the beauty of your surroundings. Then, gather maps to represent those places and cover a heart-shaped surface with them.

MATERIALS AND TOOLS

black gesso

gel gloss medium

maps and images of places that represent your heart's experiences

paintbrushes

papier-mâché heart or other heart-shaped substrate

pencil

scissors

My Map Story

As luck would have it, my local craft store had a papier-mâché heart that was perfect for my project. My maps were colorful, and I wanted them each to stand alone, to have a zing they might not possess if they ran together. To that end, I painted the heart with black gesso to give each map an outline and act as a kind of grout.

At my heart's center is a picture I drew of a Calypso iris. The flower is a symbol of the goddess Iris, the mythological messenger between the gods and the earth, the link between the divine and humanity. Iris is also represented by the image of the rainbow that connects the earth and the heavens. I made this map during a time when some of my friends had passed, and so the iris also symbolizes that time for me. The rest of the maps are of places where I felt divinely happy—while attending an art class, taking a hike or exploring the world.

Inspired by . . . Cordiform

The cordiform, or heart-shaped map, came into usage in the sixteenth century. This 1534 example is by Oronce Finé, a French cartographer. The inscription reads: "Southern land newly discovered, but not yet fully explored." Finé is referring to the Antarctic, not the heart, but the statement works in a fine sample of kismet.

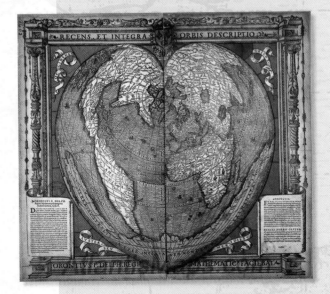

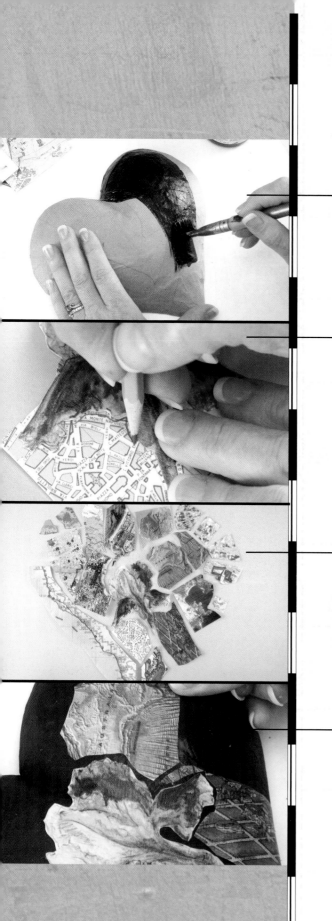

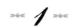

1

Paint a papier-mâché heart or other heart-shaped substrate with black gesso. Let it dry completely.

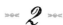

2

Gather maps and images that represent your heart's experiences. Start with a central image or map and cut it out. Determine the pieces that will be placed immediately next to the central image. Place the central image over each of these pieces and trace along the edges with a pencil. Cut along the pencil line. The objective is to create puzzle pieces that will fit on the heart, with a narrow space separating each piece. Work from the center out until you have enough pieces to cover the substrate.

3

After cutting each piece, lay it out in preparation for adhering it to the heart. For pieces that will be adhered to the top curves of the heart, it may be necessary to cut them into smaller pieces so they will lie flat against the curved surface. For example, the map of Venice on the upper-right side of the heart is cut into three pieces.

4

Adhere the central image to the heart with gel gloss medium. Continue adhering each piece, working from the center out.

5

Fold over any pieces that extend past the edge of the heart and secure them with gel gloss medium. For longer pieces, cut the excess into a "fringe" and then fold it over the edge so it lies flat.

6

After all pieces are glued, apply a final coat of gel gloss medium over the entire heart. This will seal the surface and incorporate any gel that might otherwise show.

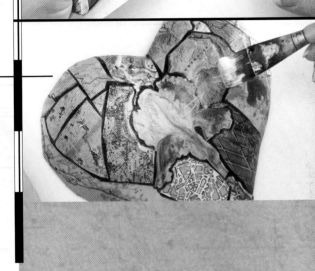

more maps of
THE SELF

Kim's Heart

Kim Rae Nugent

This map is of the geographical location of my heart, centered in the quaint little town of Cedarburg. This is where I met my husband, Mark, where he proposed and where we got married. My mom moved to Cedarburg from our family home in Mequon.

I superimposed a painting of myself over a scale drawing of Cedarburg and drew small circles to mark each significant location. I simplified the map by omitting roads that weren't vital to my story. Highway I conveniently points to my eye, the eye that searched northward to find a home, to begin and raise my family. Cedar Creek symbolizes the life force flowing through my veins that continues beyond my mortal being.

VARIATION
Computer Heart Map

This heart map is a series of islands because, at the time I made it, I felt not quite whole, and I wanted a lot of "sounds" (Sound of Laughter, Sound of Children), so I needed lots of water. Water environments—the beach, a lake or any other body of water—make my heart sing. They are where my heart is.

MATERIALS AND TOOLS

Adobe Illustrator and Adobe Photoshop, or other imaging software

map image

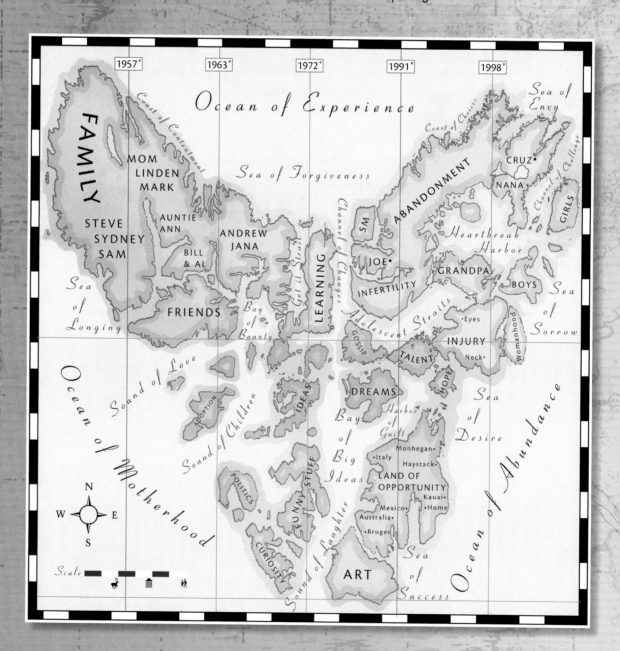

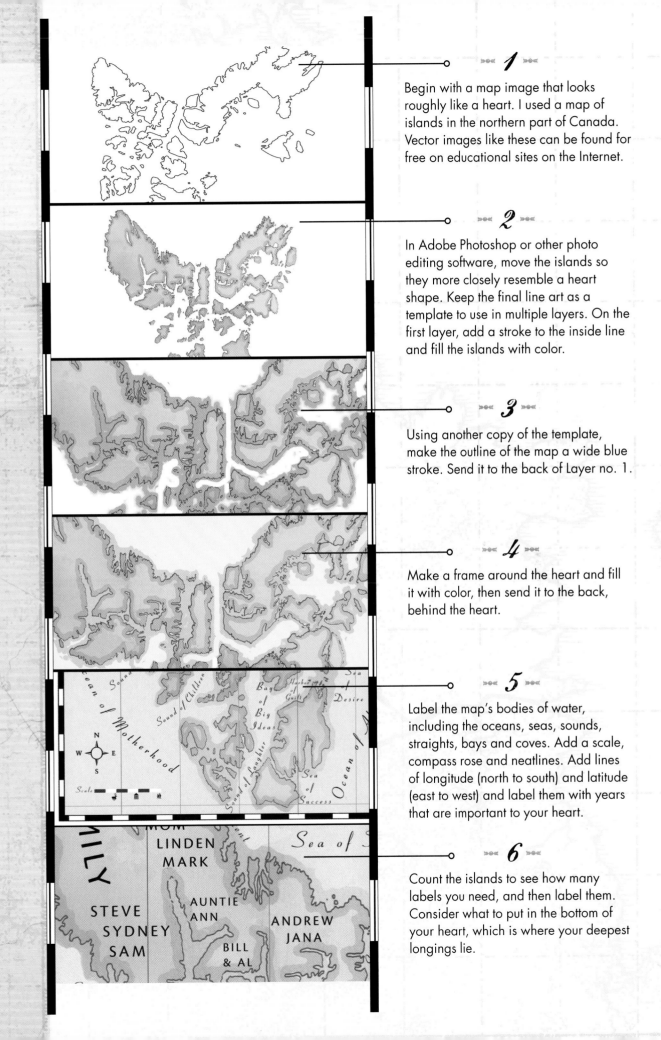

1

Begin with a map image that looks roughly like a heart. I used a map of islands in the northern part of Canada. Vector images like these can be found for free on educational sites on the Internet.

2

In Adobe Photoshop or other photo editing software, move the islands so they more closely resemble a heart shape. Keep the final line art as a template to use in multiple layers. On the first layer, add a stroke to the inside line and fill the islands with color.

3

Using another copy of the template, make the outline of the map a wide blue stroke. Send it to the back of Layer no. 1.

4

Make a frame around the heart and fill it with color, then send it to the back, behind the heart.

5

Label the map's bodies of water, including the oceans, seas, sounds, straights, bays and coves. Add a scale, compass rose and neatlines. Add lines of longitude (north to south) and latitude (east to west) and label them with years that are important to your heart.

6

Count the islands to see how many labels you need, and then label them. Consider what to put in the bottom of your heart, which is where your deepest longings lie.

44

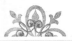

Articulated Self-Portrait

This project is a self-portrait that moves, and is composed of maps and symbols that define you. Before you begin, make a list of places that might be your legs. What places hold you up? For arms, what gives you strength? What would you reach out to? What places are simply shaped like arms? Do you want something around your head, or on top of it like a hat? What might you be holding, or stepping into? Because this portrait is articulated and moves in quirky ways, it is meant to be amusing. One cannot kick up a leg made of Italy in a serious way.

My Map Story

My portrait has legs made of California, where I grew up, and Italy, where I grew out. The arms are Baja, California and Dana Strand, California: Both had beaches that I combed and adored; I still reach out to them in daydreams. My head is surrounded by a halo made from an astrological globe, which is both beautiful and full of possibilities. In my hands, I hold a ship, for sailing off to great adventures, and a compass rose, so I won't get lost. My torso is a map of Colorado, with a gold X where my heart is: my house full of family in the town where I live.

MATERIALS AND TOOLS

cardstock

foam brush

gel matte medium

heavy object

hot foil pen or other mark-making tools

Japanese hole punch

maps and images to represent the following: arms, legs, torso, items carried in your hands and an adornment for your head

photo of your face

scissors

small brads

Inspired by . . . Pantins

Articulated paper dolls in the mid-eighteenth century were called *pantins*, French for "dancing jack puppet." The toy form continued into the Victorian era, when ballerinas and elegant ladies, clowns and children were produced in sheets like this one, with only their limbs printed on paper. The owner would fashion clothes (and a body) of their own choosing.

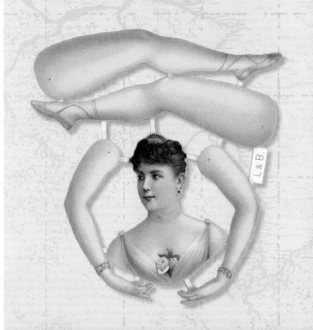

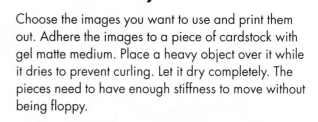

❯❯❯ 1 ❮❮❮

Choose the images you want to use and print them out. Adhere the images to a piece of cardstock with gel matte medium. Place a heavy object over it while it dries to prevent curling. Let it dry completely. The pieces need to have enough stiffness to move without being floppy.

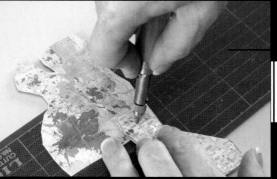

❯❯❯ 2 ❮❮❮

Cut out the pieces of the maps into body parts: a torso, arms, legs and a head. Lay them out in a body shape.

❯❯❯ 3 ❮❮❮

Place a selected limb over the torso and punch through both pieces at the same time with a Japanese hole punch.

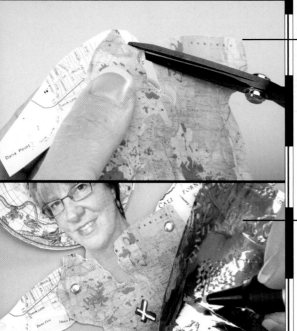

❯❯❯ 4 ❮❮❮

Before attaching the limbs to the torso, test them by swinging them up and down. Trim the limbs as necessary so they don't get caught on the head or show in places they shouldn't. Connect the arms, legs and head to the torso with small brads. Attach objects that you carry to the end of each arm.

❯❯❯ 5 ❮❮❮

Embellish the torso with a hot foil pen or other mark-making tools to identify your heart or other significant areas.

Articulated Self-Portrait

Deedee Hampton

My articulated self is comprised of maps of various states and countries that have shaped who I am, and bodies of water that represent my subconscious. My boots/roots are New Orleans and Baton Rouge, Louisiana, where I spent my formative years, and the area around Estes Park, Colorado, where I have lived on and off for the past thirty years. On the diamond-pattern tights going up my legs are maps of the different towns and cities my family moved to while I was growing up: Boulder and Denver, Colorado; Teton National Park, Wyoming; Phoenix, Arizona; Billings, Montana; Casper, Wyoming; and Tulsa, Oklahoma. Each oval segment in my skirt shows countries I have visited: France, England, Honduras, Costa Rica, Mexico, Guatemala, Belize, Japan, Cambodia, Thailand, Vietnam and India. The waist—my center—represents where I was born: Camp Lejeune, North Carolina. The heart shows where my heart is: Santa Fe, New Mexico, where I lived for nine years and long to return to someday. Inside the heart is a journaled time line reaching back to the year I was born and extending forward to the year 2040—I plan to be around for at least that long to continue the time line! I have traveled quite a bit in Mexico, and the folk art of this country influences my art. I fashioned arms from maps of this country. The earrings and necklace spell *map* and also move.

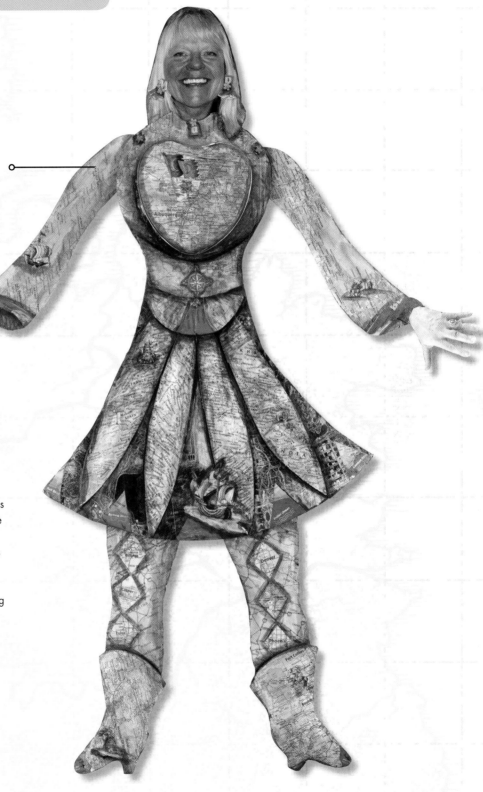

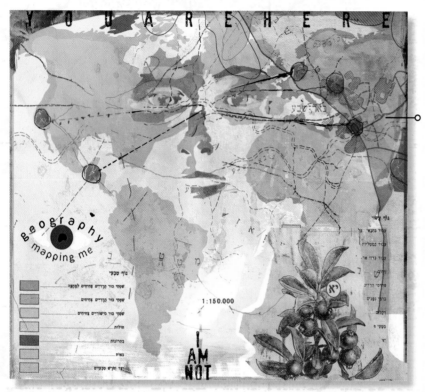

All Over the Map

Orly Avineri

I am the sum of all the places I've been, roads I've taken and sights I've seen.

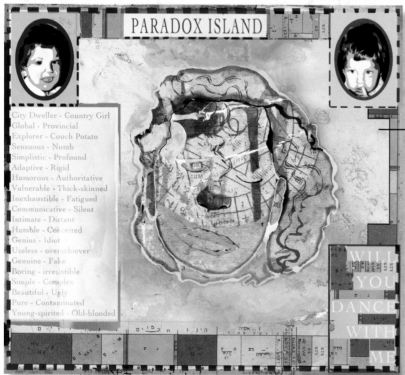

Paradox Island

Orly Avineri

A freestanding body of land and contradiction.

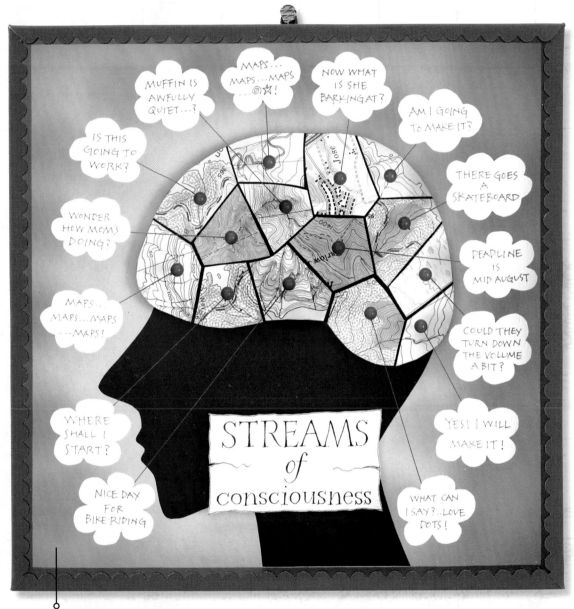

Streams of Consciousness

Mitsuko Baum

This piece represents the random thoughts that I had at my work table or elsewhere almost every day of the last six months as I worked on the projects for this book.

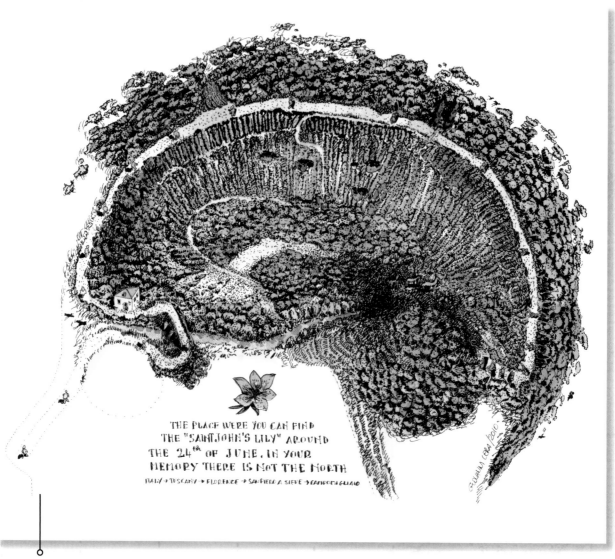

THE PLACE WERE YOU CAN FIND
THE "SAINT JOHN'S LILY" AROUND
THE 24th OF JUNE. IN YOUR
MEMORY THERE IS NOT THE NORTH

ITALY → TUSCANY → FLORENCE → SAN PIERO A SIEVE → CAMPOMIGLIAIO

Campomigliaio Head Map

Giovanni Cera

Every year around June 24, I think about my beloved flowers. June in Tuscany is warm, and the country is so fragrant in the night. Here, perhaps, deer and boars are in love, or they are eating grass or roots, or they are calling to each other. My flowers are there in a secret place only I know, and I know by heart how to find them. I know they are waiting for me and that there will be a time I'll go again to visit them and to paint them.

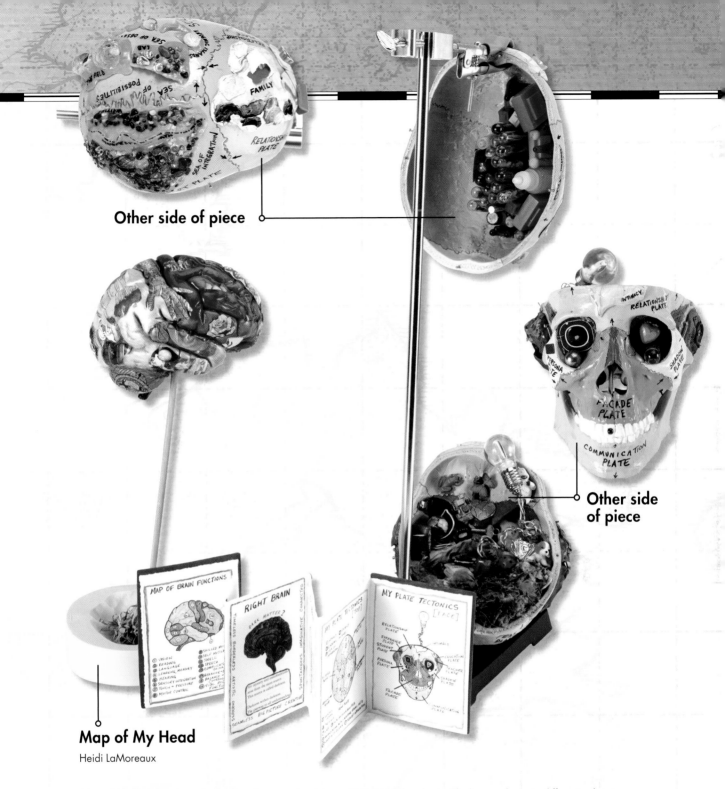

Other side of piece

Other side of piece

Map of My Head

Heidi LaMoreaux

Map of My Head explores the tensions between the right and left sides of my brain. The bones, shown in different colors in the original skull model, have been transformed into geological plates, complete with mountains, oceans and direction of movement (convergence or divergence). The skull cap, connected to a laboratory stand, illustrates four of the main tensions in my life: the interactions of art, science (I have a Ph.D. in physical geography), fear and personal relationships. The inside of the top of the head is filled with test tubes and science materials on the left side to illustrate how the left brain dissects and compartmentalizes information. The "right brain on a stick" shows where various brain actions occur, as well as the "dark side" of the brain—the mystery of creativity. The main skull piece shows additional tectonic plates, and is filled with a nest to symbolize a safe place to combine right- and left-brain activities to create new interdisciplinary ideas. The book, or "Key," shows details of each of these different parts of the map of my head.

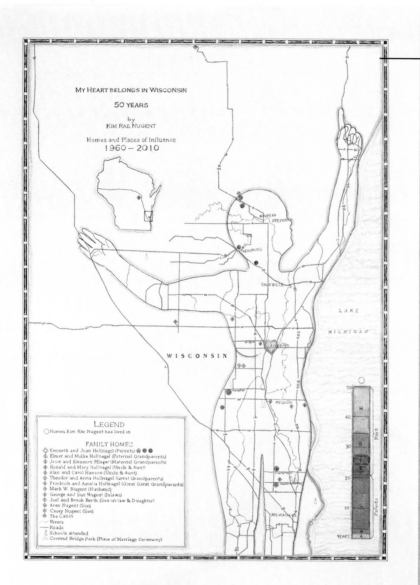

My Heart Belongs in Wisconsin

Kim Rae Nugent

I was fifty when I made this map, and it was a good time to record the geographical influences of my life. I have lived in Wisconsin since I was born, most specifically South Eastern. I photographed myself in the illustrated pose and then superimposed my figure along the shore of Lake Michigan. I enjoy the challenges of working roads and waterways drawn to scale and fitting them within the confines of a figure. The idea was worked back and forth between map image and figural image. I wanted the contours of my body to follow the Lake Michigan shoreline as closely as possible. I also wanted to incorporate all of the places that I have lived in my life within the figural form while keeping to the correct scale. Roads and rivers make up my veins and arteries. The placement of Cedarburg corresponds with my heart. My hand points upwards to where Granny lived. The road to the West leads to the Minneapolis–St. Paul area where my husband was born and where my in-laws now reside. Now grown, each of my children live outside my figural representation, but in close proximity. A graph reflecting how long I lived at each location is also included.

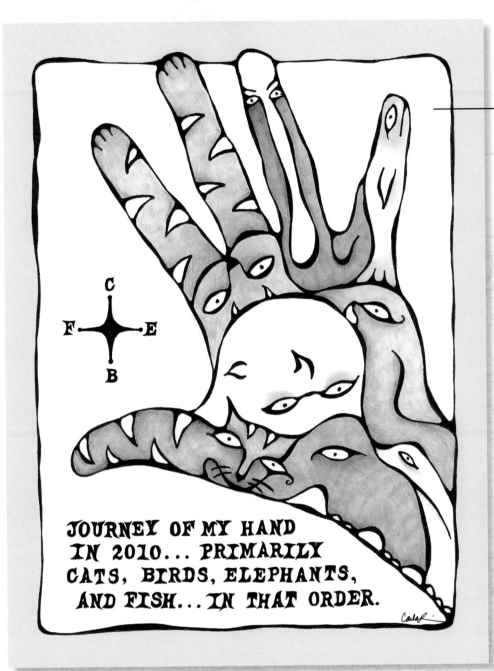

Journey of my Hand in 2010

Carla Sonheim

It took me some time to decide how to create my hand map. I really wanted to do something "mappy"—I wanted it to look like a real map! But sometimes, a theme or series grabs hold of me and I can't seem to get away from it, no matter how hard I try. Animals and creatures have dominated my sketchbooks lately, and I couldn't get them out of my head. In the end, the animals won out, like they always do. I used a black fine-point permanent marker and a combination of Copic markers, colored pencil, pencil and digital color.

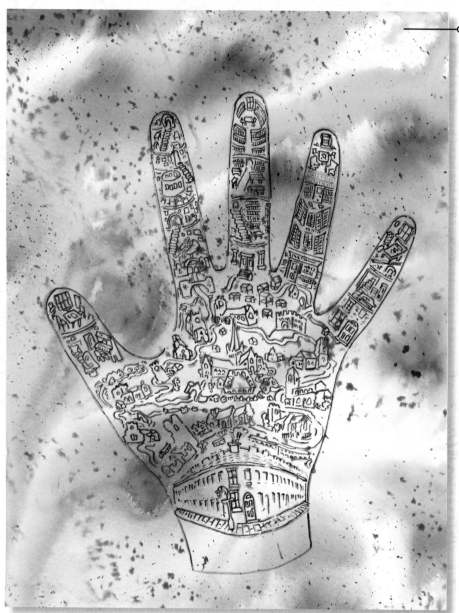

Hand Map

Paul Johnson

I grew up in the small city of Norwich in the east of England. It has thirty medieval churches; more than any other city in Europe, one on every street. Starting at the wrist is the tiny house in the middle of a Victorian terrace where, as a child, I lived with my parents in the 40s and 50s. Every Saturday afternoon, we made the same journey. Passing five medieval churches, we arrived at Norwich Museum and Art Gallery, a twelfth-century castle. We climbed the castle mount, passed through the gatehouse and entered the museum by passing through a turnstile and climbing endless flights of stairs. This is my index finger. Next we passed two more medieval churches to arrive at Norwich Public Library, which was a lovely Victorian building full of polished-brass fittings and solid-oak bookshelves and was demolished in the 60s to make way for a multistory car park. I climbed yet more stairs to reach the children's section and walked through the reading room—always full of old men reading newspapers—to reach the bookshelves where I selected the reading for the week ahead. This is portrayed on the next finger.

After rejoining my parents downstairs, we left the library and passed two more churches to reach Elm Hill, a narrow winding street full of ancient houses, in the heart of which was Mr. Higgins' second-hand book shop. It is drawn on the next finger. It was a tiny Dickensian shop with so many books they were piled up vertically. Mr. Higgins and his elderly mother lived in a tiny room at the back of the shop. Returning home, we passed three more churches and Norwich Cathedral (here drawn in the middle of the palm beneath the stalls of Norwich market). The little finger shows our front door and the narrow winding staircase up to my bedroom. My library books are lying on the bed.

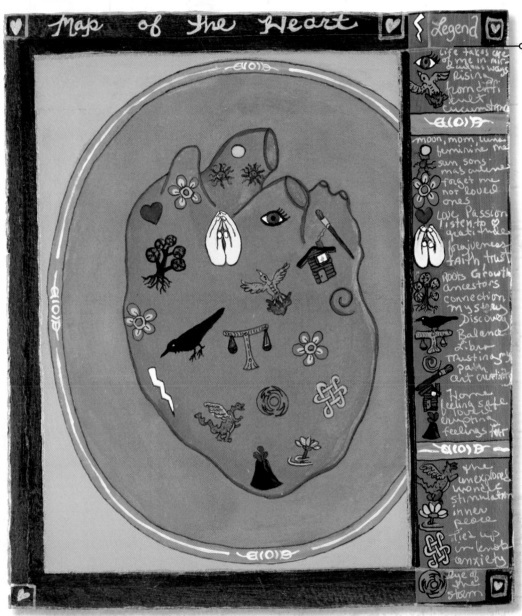

Heart of Darkness . . . and Light

Deedee Hampton

My heart map was influenced by a folk-art painting I bought in India of feet that had brightly colored symbols painted on them. I decided to map out the contents of my heart in an Indian folk-art-inspired fashion. I created symbols to represent my feelings and explained their meanings in the legend.

Newport Beach
CORONA DEL MAR
CRYSTAL COVE
☮ **LAGUNA BEACH**
WOODS COVE
SOUTH LAGUNA
MONARCH BAY
SALT CREEK
DANA POINT

COSTA MESA
LAKE FOREST
LAGUNA HILLS

MISSION VIEJO

SAN JUAN CAPISTRANO

DOHENY
CAPISTRANO BEACH
SAN CLEMENTE

N

YET ANOTHER MAP BY JILL K. BERRY

My Artistic Journey

In second grade I won an art contest drawing Bambi, which was hung at the local police station, and I thought I had arrived. In fifth grade I drew all the Snoopy characters for anyone who asked. Ninth grade brought an art award. In high school I made my first movie. Later I learned to draw; people and Yellow Page ads. After college I took up the computer, then book arts, calligraphy, and finally, mixed-media.

—ROUTES—

Forbidden Paths to racetracks Cemetery route to Judy Forbes(5) Off road route to Louise's (4)

Morning walk to work at fairgrounds Afternoon route home through field Evening drive to work uptown

Costa Peralta Junior High

CHAPTER 2
Mapping Your Experience

Our lives are made up of a series of journeys, strung together in myriad ways to make the big picture of our human experience. In this chapter, we will try to isolate some of those journeys and make maps of them: visual cartographic memoirs of our life events. As the first chapter was about identifying the experiences of your body, these maps are about the experiences of your soul.

These projects are about memories, vacations, the expanse of time and the here and now. Mapmaking can bring into focus the most salient points of each of these kinds of experiences, just by the choices you make along the way. What is the title? Which components will make the story whole? Are there lines of division (hours, years or days)? Do you need a legend? The process of making these choices and placing them on your map sets your journey in a new perspective, a transformation from mental to physical.

In my Personal Geographies class, the students don't have much time to decide what to map. That is a good thing, because their inner critics and censors do not have time to mess things up. I encourage you to limit the amount of time you spend on planning and to go with the first thing that comes to mind when you're creating your maps.

Your journey does not have to be long or elaborate; it may be small and precious. A participant in one of my classes came from a large, poor family. During the holidays, the family could not afford many gifts, so they had rituals that they shared instead, one of which was "dancing the kids to bed." The entire family would make a line and dance to the bed of each child, tuck them in and then dance to the next one. Her map was a floor plan of her childhood home, with dotted lines swirling and circling through it, representing the route of the dancers. The dots are all different colors, one for each of the twelve people who lived there. She made a legend with each person's name and color, and small images of the monsters under their beds. Her map looks like Christmas, and you can feel the dancing. It is a wonderful, enchanting visual of where her family was on those special evenings in her youth.

You do not have to travel the world, wander with gypsies or even leave your hometown to map your experiences in a rich and compelling way. This is not about profundity or impressing anyone with extravagant happenings. It is simply about exploring the journeys that bloom in your own life story and putting them on a map.

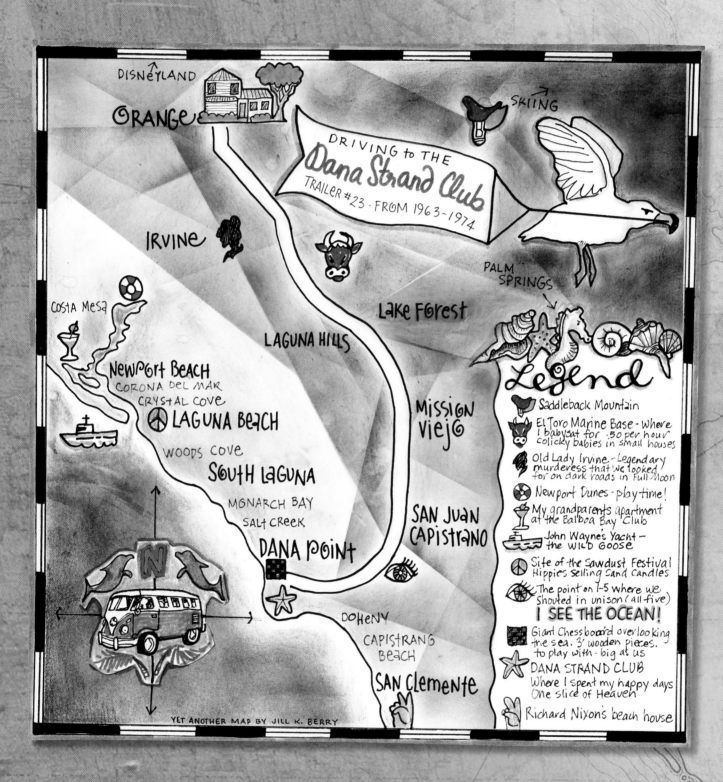

DISNEYLAND

ORANGE

SKIING

DRIVING to THE
Dana Strand Club
TRAILER #23 · FROM 1963-1974

IRVINE

PALM SPRINGS

COSTA MESA

Lake Forest

LAGUNA HILLS

Newport Beach
CORONA DEL MAR
CRYSTAL COVE
LAGUNA BEACH

MISSION VIEJO

WOODS COVE
SOUTH LAGUNA

MONARCH BAY
SALT CREEK

DANA POINT

SAN JUAN CAPISTRANO

N

DOHENY

CAPISTRANO BEACH

SAN CLEMENTE

YET ANOTHER MAP BY JILL K. BERRY

Legend

- Saddleback Mountain
- El Toro Marine Base - Where I babysat for .50 per hour colicky babies in small houses
- Old Lady Irvine - Legendary murderess that we looked for on dark roads in Full Moon
- Newport Dunes - play time!
- My grandparents apartment at the Balboa Bay Club
- John Wayne's Yacht - the WILD GOOSE
- Site of the Sawdust Festival Hippies selling Sand Candles
- The point on I-5 where we Shouted in unison (all five) **I SEE THE OCEAN!**
- Giant Chessboard overlooking the sea. 3' wooden pieces. to play with - big as us
- DANA STRAND CLUB Where I spent my happy days One slice of Heaven
- Richard Nixon's beach house

Pop-Up Memory Map

This map is about a strong memory or a tradition in your life. Did your family travel every holiday season to your grandparents' house? Is there a trip you have taken, awake or in dreams, more than once? Think of a journey that is familiar to you. Leap into this project without editing the journey in your head or worrying to much about the details.

My Map Story

Nearly every weekend of my childhood was spent at my grandparents' trailer home on the beach. My mother would pile all five of us kids in the VW van and head south toward the shore. Both sides of the highway were framed with the verdant acreage of ranches, farms and endless marching groves of citrus and avocado. Halfway through the trip, the road curved due west, and we could suddenly see the sparkling silver of the Pacific on the horizon. One of us would yell, "I see the ocean!" every single time. In my map, the compass rose is our VW van, flanked by the dolphins that still leap in the Pacific.

The highway I remember so well is now bordered by condos, strip malls, car dealerships and fast-food eateries. Not one plot of ranchland survives. Making this map restored the pastoral and youthful beauty of that journey and the fresh smell and sight of it, if just for a short time.

MATERIALS AND TOOLS

1—8" × 8" (20cm × 20cm) piece of copier paper

1—4¼" × 11" (11cm × 28cm) piece of cardstock

4B–8B pencil

black fine-tip permanent marker

colored pencils

drawing pencil

dye ink pads

hard pencil

scrap paper

stencil brushes

straightedge

tracing paper

white glue

Inspired by . . .
Henry Van Dyke

"Memory is a capricious and arbitrary creature. You never can tell what pebble she will pick up from the shore of life to keep among her treasures, or what inconspicuous flower of the field she will preserve as the symbol of 'thoughts that do often lie too deep for tears.' . . . And yet I do not doubt that the most important things are always the best remembered."

— Henry Van Dyke, 1852

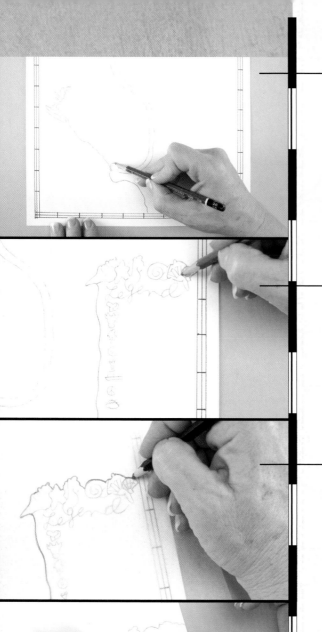

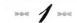
Draw the neatlines around the edge of a piece of copier paper using a pencil and a straightedge. Sketch a basic map, including the starting point and ending point of the journey and the road connecting them. Don't worry about being accurate; just draw it as it appears in your head.

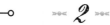
Decide what symbols you would like to use on the map and draw them. Estimate how much space you will need for each of the symbols and their descriptions. Block in the legend onto a part of the map that won't cover up something necessary.

Place tracing paper over the legend and trace the outline of the legend box onto the tracing paper. Flip the tracing paper over and shade over the drawn line with a 4B–8B pencil to make a transfer.

Place the shaded side of the tracing paper on top of a piece of scrap paper. With a hard pencil, transfer the outline of the legend onto the paper. Cut out the template and use it to shield the legend area from the dye inks.

Tamp the stencil brush into the dye ink pad you want to start with. Pounce it onto the background of the map. Make the background colors light, so layers on top will show. If you start with dark layers, you can't layer over them, so it is best to build up the color with many layers, going from light to dark.

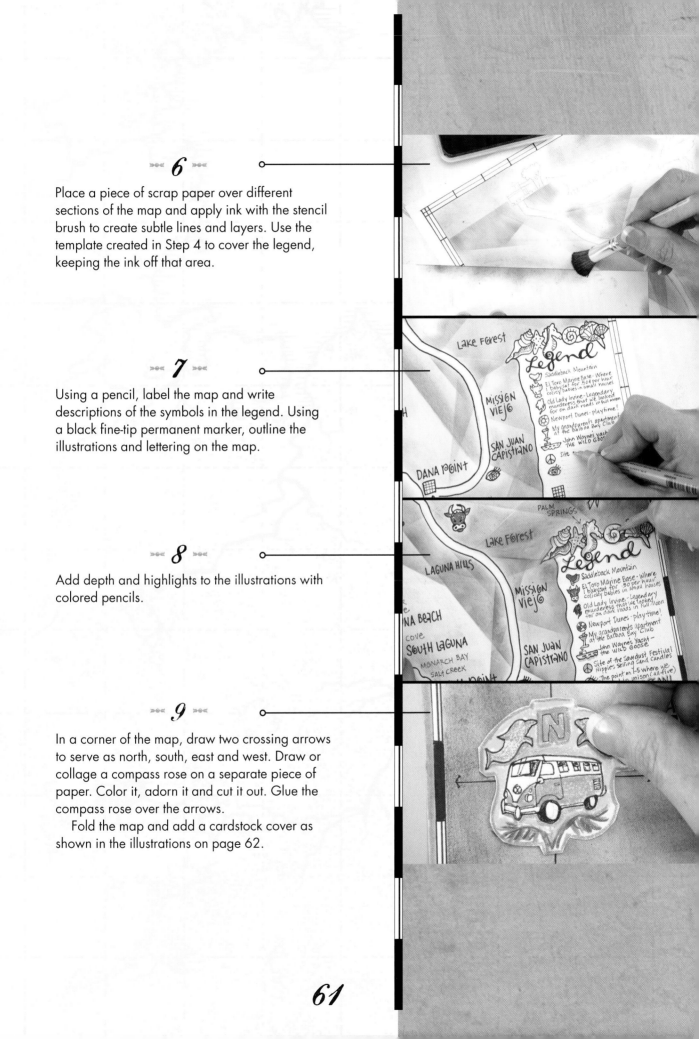

⤜ **6** ⤛

Place a piece of scrap paper over different sections of the map and apply ink with the stencil brush to create subtle lines and layers. Use the template created in Step 4 to cover the legend, keeping the ink off that area.

⤜ **7** ⤛

Using a pencil, label the map and write descriptions of the symbols in the legend. Using a black fine-tip permanent marker, outline the illustrations and lettering on the map.

⤜ **8** ⤛

Add depth and highlights to the illustrations with colored pencils.

⤜ **9** ⤛

In a corner of the map, draw two crossing arrows to serve as north, south, east and west. Draw or collage a compass rose on a separate piece of paper. Color it, adorn it and cut it out. Glue the compass rose over the arrows.

Fold the map and add a cardstock cover as shown in the illustrations on page 62.

Folding Instructions

A. Fold the map in half vertically, holding the map as it reads, with wrong sides together (Fold 1). Unfold.

B. Fold the map in half diagonally, right sides together (Fold 2). Unfold.

C. Fold the map in half diagonally in the opposite direction, right sides together (Fold 3). Unfold.

D. Refold Fold 1 with right sides together.

E. Bring the sides of Fold 1 together in the center. You should have a triangular paper cup.

F. Bring the pointed flaps to the center, one at a time, lining the upper edges together. Crease the sides firmly. Do this on all four sides until you have a house shape.

G. Unfold the flaps and reverse them, pushing them inside the center with the creases you just made.

H. Set the folded map inside the cover, centering the point just outside of the fold. Add glue as shown and close the cover.

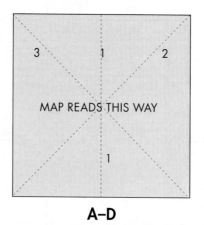

A–D

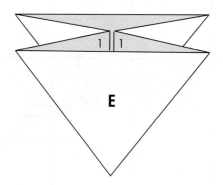

E

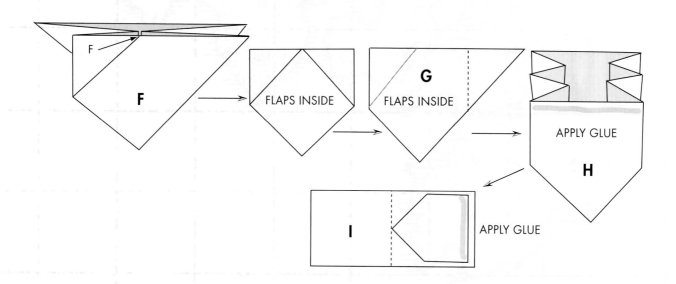

Swannanoa
Dreamtime Passage

Gwen Diehn

I had spent the summer working on an archaeological site on the college campus where I live, and this map shows a nearby field where the Swannanoa River was known to have passed in archaic times. You can still see the low creek bed down the center of the field, what the Chinese call a "frolicking green water dragon" in their geomantic system. I was interested in showing how the field felt rather than its scientific features and roads.

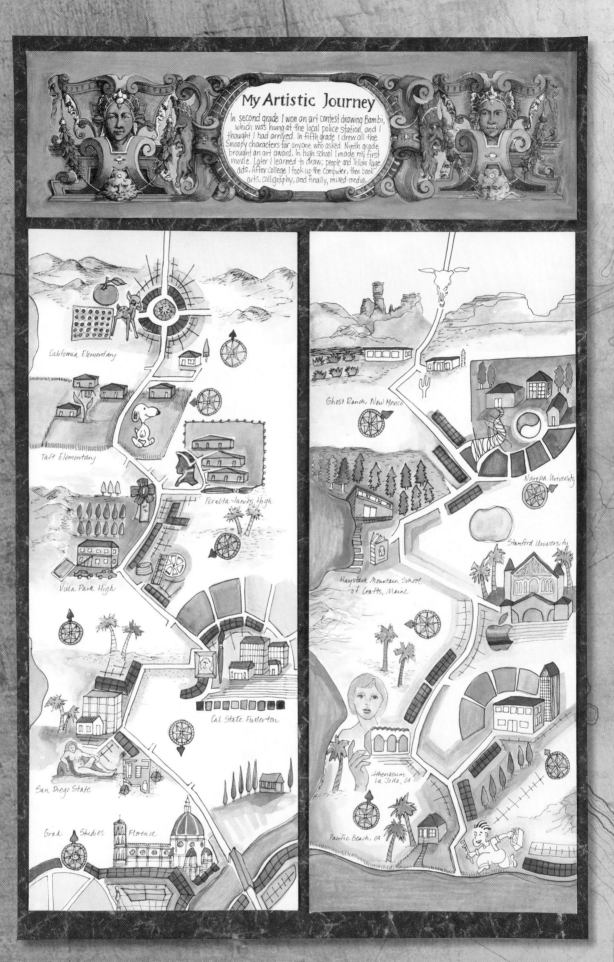

My Artistic Journey

In second grade I won an art contest drawing Bambi, which was hung at the local police station, and I thought I had arrived. In fifth grade I drew all the Snoopy characters for anyone who asked. Ninth grade brought an art award. In high school I made my first movie. Later I learned to draw; people and Yellow Page ads. After college I took up the computer, then book arts, calligraphy, and finally, mixed-media.

California Elementary

Taft Elementary

Peralta Junior High

Villa Park High

San Diego State

Grad Studies Florence

Cal State Fullerton

Ghost Ranch, New Mexico

Naropa University

Stanford University

Haystack Mountain School of Crafts, Maine

Athenaeum La Jolla, CA

Pacific Beach, CA

Your Artistic Journey

How did you get to where you are now? Using the strip-map model, you will make a linear depiction of a nonlinear journey on two or more strips of paper. The map reads up and down and back up again as many times as you like, and each event is joined by a simple line. The road is fairly straight, and the only indicator that the direction changes is the orientation of the compass rose.

Make a list of places that led you to where you are today. Then, create a map of those places. They can illustrate an artistic journey, like mine, another career or personal path, or simply places you have lived.

My Map Story

In order to create this map, I really had to think about where my path has led me. When and where were my *a-ha* moments? Who, among my many teachers, struck pay dirt in my artistic soul? I made a list of significant events, teachers and places, and hooked them all together to illustrate my artistic journey. Some of the events I've illustrated on my map:

• While attending California Elementary School in the second grade, I drew Bambi and won a prize. The winning picture was hung at the local civic center, and I walked my seven-year-old self two miles from home to see it. I gazed at the picture on the wall, and knew I had reached the apex of my art career.

• While at Taft Elementary School, I practiced drawing all the *Peanuts* characters and drew them for the teachers' bulletin boards.

• After college, I lived by the beach and drew ads for the Yellow Pages: plumbers, floral displays and cars, among other exciting subjects. I paid off my student loans and went on to graphic design.

MATERIALS AND TOOLS

1—3¾" × 12⅜" (9.5cm × 31.5cm) piece of heavyweight paper

1—12¾" × 19½" (32.5cm × 49.5cm) piece of complementary colored backing paper

1—13¾" × 20½" (35cm × 52cm) piece of mat board

2—6 " × 14¾" (15cm × 37.5cm) panels of watercolor paper

black fine-tip waterproof marker

cartouche image

eraser

fine-tip paintbrush

printer

straightedge

watercolors

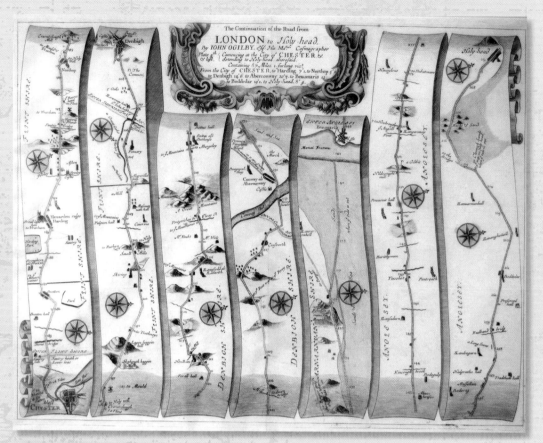

Inspired by . . . *John Ogilby*

John Ogilby was born in Scotland in 1600. His father went to debtor's prison, and the young John sold trinkets to support his mother and siblings. He bought a winning lottery ticket, and, with the proceeds, purchased his father's bail and eventually a dance school. In his twenties, misfortune struck: He fell in a performance that left him lame and ended his dancing career.

After many adventures, including surviving a shipwreck, John opened a publishing house in London and used his knowledge of Latin and Greek to make printed translations of the Bible, as well as the works of Virgil, Homer and Aesop. Ill fate struck him again in 1666 when the great fires of London consumed his entire publishing empire.

Ogilby persevered and set up a new printing house from which he produced magnificently illustrated books. In his penultimate career move, John and his grandson were hired to survey the city of London. The map that resulted led him to be named to the position of His Majesty's Cosmographer and Geographic Printer. The first year on the job, he produced *The Britannia Atlas*, which set the standard for the road maps that followed, and included over one-hundred maps, such as the one above. This style of map later became the TripTik that was used in paper form by travel agencies for years, and is used in a digital form today.

⊰ *1* ⊱

Arrange the desired number of watercolor paper panels on your work surface. I used two panels measuring 6 " × 14¾" (15cm × 37.5cm). Sketch circles onto the panels to indicate each event in your journey, evenly spacing them. If there are ten steps on two panels, there will be five circles on each panel. Draw a line to connect each circle. The lines can run at slight angles or straight down.

⊰ *2* ⊱

Use the illustration sample on page 69 as inspiration for sketching out your journey. Sketch the entire journey with a pencil, adding images and elements from the sample as desired. Erase the circles as you work. For each step of the journey, draw a compass rose (or use clip art) that indicates the direction this step is facing.

⊰ *3* ⊱

Paint the illustrations using watercolors.

⊰ *4* ⊱

Outline the illustrations using a black fine-tip waterproof marker, marking over the watercolors.

Tip

Apply the watercolors one at a time so you don't have to continually wash your brush. Doing this will also help you see how the colors balance over the page, so you can achieve a pleasing visual effect.

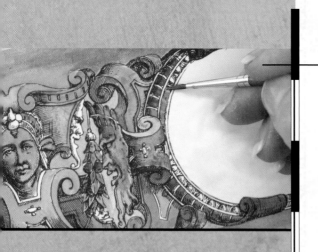

≫≪ 5 ≫≪

Print a copyright-free cartouche onto heavyweight paper for the title section. Paint the image with watercolors, leaving some areas white to add dimension.

Tip

If you print the cartouche using an inkjet printer, wait until the ink has dried completely before painting the cartouche.

≫≪ 6 ≫≪

Letter your title in the center with a pencil, then outline it with a black fine-tip waterproof marker.

Tip

To center the title, count the letters and begin with the middle letter. Add letters on both sides of the middle letter in pencil to block out and to balance the title.

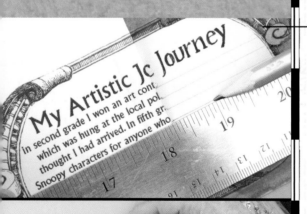

≫≪ 7 ≫≪

Measure the space reserved for the description. Type and print out a description that will fit within the space. Fold the typed description in half and match it up with the description space. Using a pencil and a straightedge, draw guidelines onto the space, using the typed description to determine the number of lines. Your lettering should be about the size of the typed letters. Write the description in the space, first in pencil, and then with a black fine-tip waterproof marker.

≫≪ 8 ≫≪

Mount the map panels and the header onto a complementary color of backing paper. Mount the backing paper onto a piece of mat board.

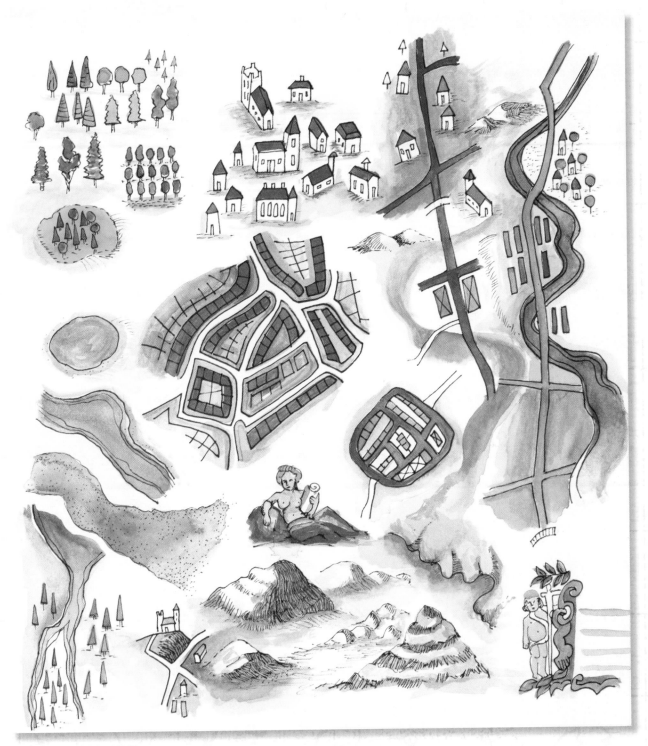

ILLUSTRATION SAMPLE
Use these simple symbols, inspired by John Ogilby, in your own map: popsicle trees, block houses, simple roads and geometric towns.

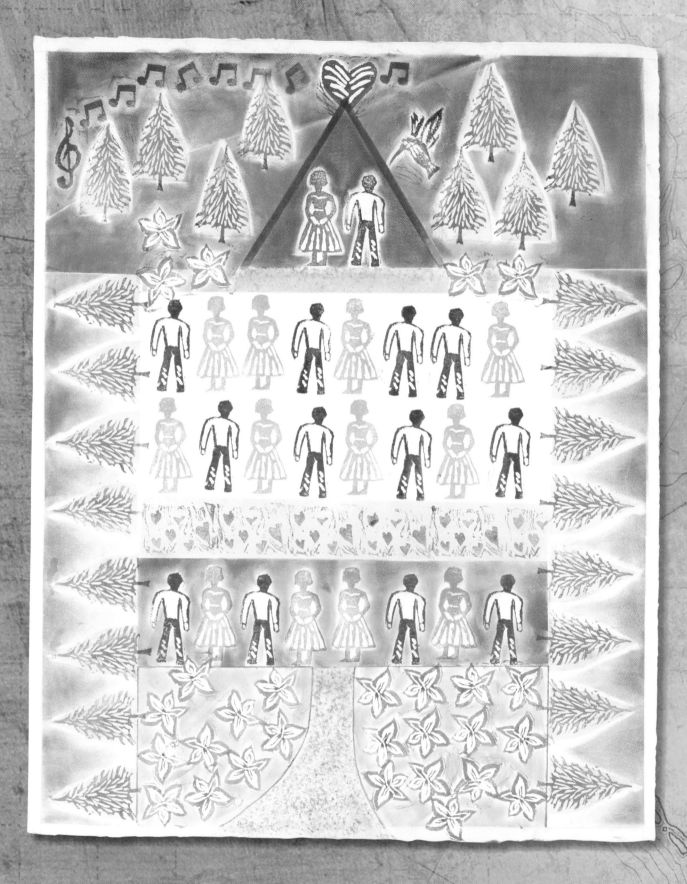

The Right Place at the Right Time

Can you recall an event in which you were in exactly the right place at precisely the right time? Pick a place in time or space that can be represented by a few symbols. The symbols should be repetitive, to show quantity, and limited, to simplify the scene and make it readable.

My Map Story

This is a map of my wedding day, a lovely day in the woods in Southern California. I made a list of the elements that were essential to that day:

- People
- Love
- Music
- Flowers
- Trees
- The hummingbird that hovered between my husband and me when we said our vows

MATERIALS AND TOOLS

1—18" × 24" (46cm × 61cm) piece of watercolor paper

4B–8B pencil

acrylic stamp plates

alcohol ink pads

baby wipes

clip-art images for your chosen symbols

craft knife

cutting mat

double-sided tape

drawing pencil

eraser

hard pencil

Mylar sheets

PanPastels

paper towels

rubber texturing tool

scissors

scrap paper

Sofft knife with sponge cover or triangular cosmetic sponge

stamp carving tools

stamp material

straightedge

vellum sheets

waterproof pen (optional)

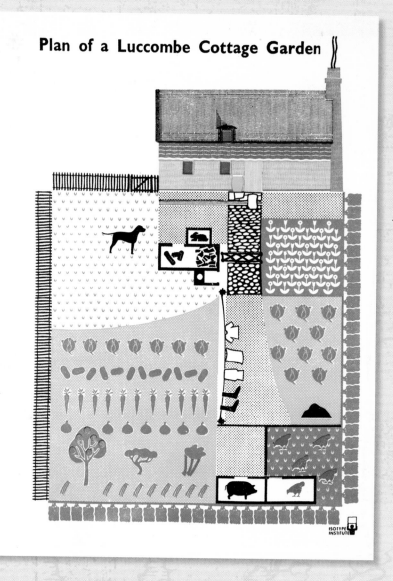

Plan of a Luccombe Cottage Garden

Inspired by . . . *Otto Neurath*

This project draws its inspiration from the work of Otto Neurath, an Austrian philosopher of science, sociologist, writer and political economist born in Vienna in 1882. Most of us have never heard of him, yet he created the pictorial language of symbols that we take for granted on a daily basis. The stiff silhouettes on restroom doors, the figure in mid-stride ready to cross the street, the car leaving swervy lines in its wake, the erect palm that halts us at intersections—these symbols, scattered across the globe, visually inform us of what to do, where to go and what to expect around the bend. They are now considered universal, but before the vision of Otto Neurath, they simply did not exist.

Otto's childhood attraction to Egyptian hieroglyphics became a lifelong passion. As a socialist who was interested in utility over art, he sought out a way for anyone, in any culture, to share a visual language that imparted complex ideas from easily interpretable icons. This universal visual language, he believed, would harmonize the world. The symbols he created are simple silhouettes, which he called isotypes. Otto, his wife Marie, and designer Gerd Arnst worked as a team to reduce each idea to its simplest form. They set up the Isotype Institute in Oxford, England, in 1942. Otto died in 1945, but his wife continued to work with isotypes in education until her death in the 1980s.

1

Choose a clip-art image for each of the elements that will appear on your map. Cut a piece of stamp material large enough to accommodate your chosen clip-art image.

2

Flip the desired image over and shade over its entirety with a 4B–8B pencil. Place the shaded side on top of the stamp material. Use a hard pencil to transfer the image onto the stamp block. Refine the image with a pencil or a waterproof pen.

3

Cut away the negative space (the part you do not want to print) with stamp carving tools. When the carving is complete, test the stamp on a scrap paper and see if it needs to be refined. Make adjustments. Trim the edges of the stamp block with a bevel cut so they recede far enough that they do not print.

4

Mount the stamp to an acrylic stamping plate with double-sided tape to achieve even pressure and make it easier to use. Repeat Steps 1–4 with the remaining clip-art images.

⟫⟩⟫ *5* ⟫⟫⟨

Block out your piece onto watercolor paper using the measurements of each stamp. Plan where you want each symbol to go, and in what quantity. For example, if you are using trees, multiply the number of trees you want to find the total measurement of the area they will take up. For ten trees that are 2" (5cm) wide, you will need 20" (51cm) of space.

⟫⟩⟫ *6* ⟫⟫⟨

For the tree stamps, I wanted a two-tone effect, so I created a solid block of color behind each one with a simple triangle stencil cut from Mylar. Many stamp inks smear, so apply ink from the top of the page down.

⟫⟩⟫ *7* ⟫⟫⟨

Continue adding stamps in the designated places on your page. I wanted rows of people and rows of hearts, so I blocked out space for them and drew guidelines with a pencil.

⟫⟩⟫ *8* ⟫⟫⟨

For the hummingbird stamp, I applied three different colors of ink to create a more vibrant image.

Tip

Clean stamps with baby wipes instead of dipping them in water. Water may get trapped in small cracks in the stamp, and you could end up with a little river on your page from drizzling water, and believe me, you don't want that. Keep paper towels nearby to clean off residue.

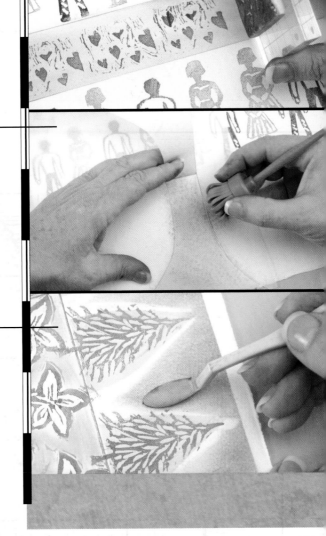

➳ *9* ➳

In some sections, I applied a solid block of color and let it dry. Then, I stamped over the solid section with one of the symbols.

➳ *10* ➳

A piece of vellum can make a very handy masking tool. I traced a path onto a sheet of vellum and cut along the lines. I flipped the "path" section of the vellum up so the sides of the path were masked and the path was exposed. Using a rubber texturing tool, I applied a contrasting ink to the pathway to create a "wooded" texture. I used the path flap to cover the path as I applied ink to the areas around it.

➳ *11* ➳

Erase all the guidelines. Color the areas around the stamped images using PanPastels and a Sofft knife with a sponge cover or the tip of a triangular cosmetic sponge.

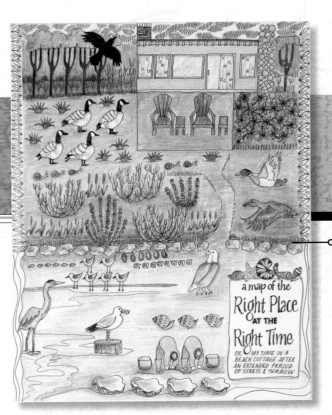

more maps of EXPERIENCE

The Right Place at the Right Time

Jill Berry

I drew this map while I was staying at a small cottage on a bay, after a period of profound sadness and loss. I had rented this cottage as a gift to myself, and when I arrived, I instantly began to feel healed. My days there were like an ongoing beautiful film: the sea air, the birds, the oyster fishermen that fished according to the dramatic sweep of the tide. There was a bald eagle that would swoop around the cottage and land right in front of me on the shore, showy and fierce. At the end of my stay, I was filled with gratitude and grace.

75

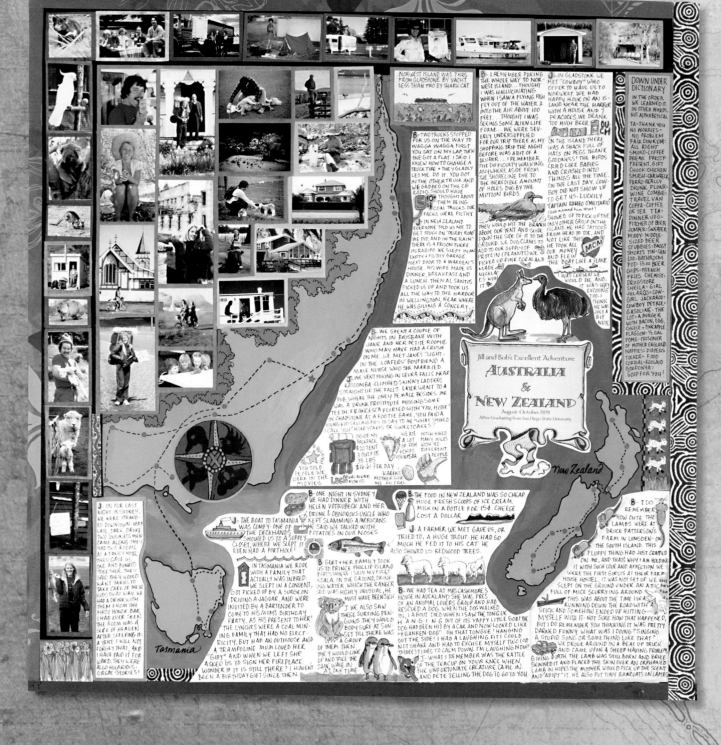

NOR WEST ISLAND WAS 7 HRS FROM GLADSTONE BY YACHT. LESS THAN TWO BY SHARK CAT.

I REMEMBER PUKING THE WHOLE WAY TO NOR WEST ISLAND... THOUGHT I WAS HALLUCINATING WHEN I SAW A FLYING FISH FLY OUT OF THE WATER & INTO THE AIR ABOUT 100 FEET... THOUGHT I WAS SEEING SOME ALIEN LIFE FORM... WE WERE SEVERELY UNDERSUPPLIED FOR OUR TRIP THERE AS MY SHOPPING TRIP THE NIGHT BEFORE WAS A BIT OF A BLURRER... I REMEMBER THE DIFFICULTY WALKING ANYWHERE, ASIDE FROM THE SHORELINE DUE TO THE INCREDIBLE AMOUNT OF HOLES DUG BY THE MUTTON BIRDS

THEY WOULD HIT THE BRANCH ABOVE OUR TENT AND SLIDE DOWN THE SIDE OF IT TO THE GROUND. WE DUG CLAMS TO ADD TO OUR SUPPLY OF PROTEIN (PEANUTS) WE PICKED UP PINK CORAL AND MADE NECKLACES WITH IT

IN GLADSTONE WE MET "COWBOY" WHO OFFER TO HAUL US TO NOR WEST. WE HAD HAPPY HOUR ON AN ISLAND NEAR THE HARBOR WITH A HOUSE AND 7 PEACOCKS. WE DRANK TOO MUCH BEER **OUCH**

ON THE ISLAND THERE WAS A SHACK FULL OF HATS ON PEGS. THANK GOODNESS THE BIRDS CRIED LIKE BABIES AND CRASHED INTO THINGS ALL THE TIME. ON THE LAST DAY, COWBOY DID NOT SHOW UP TO GET US. LUCKILY "CAPTAIN RAMBO O'MILITARIO" (Bob named him that) SHOWED UP TO PICK UP THE ONLY OTHER GROUP ON THE ISLAND. HE HAD TATTOOS FROM HEAD TO TOE, AND NOT LIKE THIS. HE TOOK ALL OUR MONEY AND FLEW THE BOAT LIKE A PLANE

I WAS CERTAIN WE WOULD DIE. AND IT WAS VERY EXCITING TOO.. I THINK HE WAS JUST A BIT NUTS

DOWN UNDER DICTIONARY
IN THE ORDER WE LEARNED IT. IN OTHER WORDS, NOT ALPHABETICAL

TA- THANK YOU
NO WORRIES- NO PROBLEM
FAIR DINKUM- ALL RIGHT
SMOKO- COFFEE BREAK
PRESSY- PRESENT, GIFT
CHOOK- CHICKEN
SMASH- CARWRECK
PARRO- REALLY DRUNK
PLONK- WINE
ZOMBIE- TRAVEL VAN
CUPPA- COFFEE OR TEA
TEA- DINNER
JUG- PITCHER OF BEER
JUMPER- SWEATER
MIDDY- MIDDLE-SIZED BEER
STUBBIES- BAGGY SHORTS
TIN- CAN
LOO- BATHROOM
POT- 13 oz BEER
CHIPS- FRENCH FRIES
DRUGSTORE
SHEILA- GIRL
JILLAROO- COWGIRL
JACKAROO- COWBOY
PETROL- GASOLINE
THE LOT- A BURGER WITH BACON, EGG, CHEESE + PINEAPPLE
FLAGGON- ½ GAL
POME- PRISONER OF MOTHER ENGLAND
NAPPIES- DIAPERS
TUCKER- FOOD
CORDIAL- KOOLAID
GOODONYA- GOOD FOR YOU!

WE SPENT A COUPLE OF NIGHTS IN BRISBANE WITH JANE AND HER PETITE ROOMIE WHO MAY HAVE HAD A CRUSH ON ME. WE MET JANE'S "LIGHT-IN-THE-LOAFERS" BOYFRIEND A MALE NURSE WHO SHE MARRIED.
WE WENT HIKING IN LEURA FALLS NEAR KATOOMBA- CLIMBED SKINNY LADDERS STRAIGHT UP THE FALLS! LATER WENT TO A PUB, WHERE THE ONLY MALE BESIDES ME WAS A DRUNK PROSTITUTE MISSING SOME TEETH. FRANCESCA FLIRTED WITH YOU, HOTIE!
IN GLADSTONE AT A FOOTIE GAME, YOU PAID A YOUNG KID SELLING PIES TO SAY TO ME "WHAT SHOULD I CALL YOU" HOTCAKES OR SWEETCAKES?

Jill and Bob's Excellent Adventure
AUSTRALIA & NEW ZEALAND
August-October 1979
After Graduating from San Diego State University

New Zealand

INSIDE MY BACKPACK
$20 TENT
3 OUTFITS
35 LBS
$16-61 PER DAY

WE ATE: CHIPS + VINEGAR

HITCH HIKED A LOT- MANY MILES & FUN WITH 40 DIFFERENT PEOPLE

YOU TOLD PEOPLE WE WERE IN THE MOVIES

LUCK WAS ALWAYS WITH US

KAREN'S MOTHER GAVE ME AN OPAL

ONE NIGHT IN SYDNEY WE HAD DINNER WITH HELEN VOTRUBECK AND HER DRUNK & OBNOXIOUS UNCLE WHO KEPT SLAMMING AMERICANS. HE SAID WE TALKED WITH POTATOES IN OUR NOSES

THE BOAT TO TASMANIA WAS COMFY. ONE OF THE DECKHANDS SHOWED US TO A SUPPLY CLOSET, WHERE WE SLEPT. IT EVEN HAD A PORTHOLE!

THE FOOD IN NEW ZEALAND WAS SO CHEAP. HUGE FRESH SCOOPS OF ICE CREAM, MILK IN A BOTTLE FOR 15¢, CHEESE COST A DOLLAR

A FARMER WE MET GAVE US, OR TRIED TO, A HUGE TROUT. HE HAD SO MUCH HE FED IT TO HIS CAT. HE ALSO SHOWED US REDWOOD TREES.

ON OUR LAST NIGHT IN SYDNEY, WE WERE STRANDED DOWNTOWN VERY LATE. DARN. BROKE TWO BUSINESSMEN CAME ALONG. THEY HAD TWO ROOMS AT A FANCY HOTEL. THEY GAVE US ONE AND BUNKED TOGETHER. THEY SAID THEY WOULD WANT YANKS TO TAKE CARE OF THEIR KIDS THAT WAY. WE HAD A DRINK WITH THEM FROM THE FIRST HONOR BAR I HAD EVER SEEN. THE ROOM WAS A SLICE OF HEAVEN AFTER SLEEPING IN A TENT. I WILL NOT FORGET THAT. AND I HAVE PAID IT FORWARD. THEY WERE ALSO HILARIOUS- GREAT STORIES!

IN TASMANIA WE RODE WITH A FAMILY THAT ACTUALLY WAS INBRED. WE SLEPT IN A CONVENT. GOT PICKED UP BY A SURGEON DRIVING A JAGUAR. AND WERE INVITED BY A BARTENDER TO COME TO HIS SONS BIRTHDAY PARTY, AS HIS PRESENT TO HER! THE LYNCHES WERE A COAL MINING FAMILY THAT HAD NO ELECTRICITY, BUT HAD AN OUTHOUSE AND A TRAMPOLINE. WHEN WE LEFT SHE ASKED US TO SIGN HER FIREPLACE. WONDER IF IT IS STILL THERE? I HAVEN'T BEEN A BIRTHDAY GIFT SINCE THEN

GERT + HER FAMILY TOOK US TO PRINCE PHILLIP ISLAND. THAT'S WHERE I SAW MY FIRST KOALA, ON THE GROUND, DRINKING WATER, WHICH THE RANGER SAID WAS HIGHLY UNUSUAL. HE MUST HAVE BEEN SICK

WE ALSO SAW THESE SURFING PENGUINS. THEY WOULD BODY SURF AT SUNSET TIL THERE WAS A GROUP OF THEM. THEN THEY WOULD LINE UP AND TAKE THE SAME WAVE IN AT ONE TIME

WE HAD TEA AT MRS CASHMORE'S HOUSE IN AUCKLAND. SHE WAS PRES. OF AN ANIMAL LOVERS GROUP AND HAD RESCUED A DOG. WHEN THE DOG WALKED IN, I ABOUT DIED WHEN I SAW THE TONG OF HANGING OUT OF ITS YAPPY LITTLE GOB! THE DOG HAD BEEN HIT BY A CAR AND NOW LOOKED LIKE "FRANKEN-DOG". OH THAT TONGUE! HANGING OUT THE SIDE! I WAS LAUGHING FIT I COULD NOT SHAKE AND HAD TO EXCUSE MYSELF TWO (OR THREE) TIMES TO CALM DOWN. I'M LAUGHING NOW! J-WHAT I REMEMBER WAS THE RATTLE OF THE TEACUP ON YOUR KNEE WHEN THE UNFORTUNATE CREATURE CAME IN AND PETE TELLING THE DOG TO GO TO YOU

Tasmania

I DO REMEMBER HOW CUTE THE LAMBS WERE AT BRUCE PATTERSON'S FARM IN LUMSDEN- ON THE SOUTH ISLAND. THIS FLUFFY THING HAD JUST CRAPPED ON ME, AND THAT'S WHY I AM HOLDING IT WITH SUCH LOVE AND AFFECTION. WE WERE THE FIRST GUESTS AT THEIR FARM HOUSE HOSTEL. IT WAS NOT SET UP. WE SLEPT ON THE GROUND UNDER AN ATTIC FULL OF MICE SCURRYING AROUND. THIS WAS ABOUT THE TIME I WAS RUNNING DOWN THE ROAD WITH A STICK AND SOMEHOW ENDED UP HITTING MYSELF WITH IT- NOT SURE HOW THAT HAPPENED, BUT I DO REMEMBER YOU THINKING IT WAS PRETTY DARNED FUNNY. WHAT WAS I DOING? SINGING A STUPID SONG OR SOMETHING LIKE THAT? WE DROVE AROUND IN A BEAT UP TRUCK AND CAME UPON A SHEEP HAVING PROBLEM GIVING BIRTH. THE LAMB WAS STILL BORN AND BRUCE SKINNED IT AND PLACED THE SKIN OVER AN ORPHANED LAMB IN HOPES THE MOTHER WOULD PICK UP THE SCENT AND "ADOPT" IT. HE ALSO PUT TINY RAINCOATS ON LAMBS

Collaborative Map

Make a map of a place or experience that you shared with one or more people. This could be that one holiday when your relatives piled into one house and Uncle Newt made a scene. It could be a vacation, a time at the cabin your family has visited for years, a year in the dorm with roommates, the boating trip to Greece with your grandmother, a hike with your child. Anything you did with at least one other person that you want to explore and remember will work.

What happens when you delve into a shared memory is surprising and revealing. As these memories unfold, you may see that your experience was remarkably different from that of the person you shared it with. Your stories may match up and they may not, because what enchants, entertains and disturbs is unique to each of us. Whatever the results, this project is bonding, fun and, most of all, surprising.

MATERIALS AND TOOLS

1—18½" × 18½" (47cm × 47cm) piece of watercolor paper

1—21" × 21" (53.5cm × 53.5cm) piece of mat board

black fine-tip permanent marker

brightly colored paper

clip-art cartouche image

clip-art compass rose image

colored pencils or markers

ephemera from your trip

gouache paints

map pins (optional)

paintbrushes

paper hole punch

paper strips or ribbon

pencil

photos of your trip

white glue

My Map Story

Just after I graduated from college, a fellow graduate and I took a trip to eastern Australia and New Zealand. Very few Americans had made their way down under at that time, so we were the first "Yanks" that most of the locals had ever encountered. As such, we were treated almost like celebrities. We hitchhiked most of the time, and were picked up by families, surgeons, truck drivers and tattooed pirates. The drivers gave us gifts and invited us over for meals and lodging. The entire trip was enchanted and full of great adventure.

It has been many years since this trip, but the memories of it have consistently returned to me. My friend and I reconnected, and I came up with the idea of mapping our trip together. My friend sent his photos and memories, and I gathered up mine and made a sketch of the route we had taken. I compiled printouts and photos until I figured out the overall size of the map and started the collage.

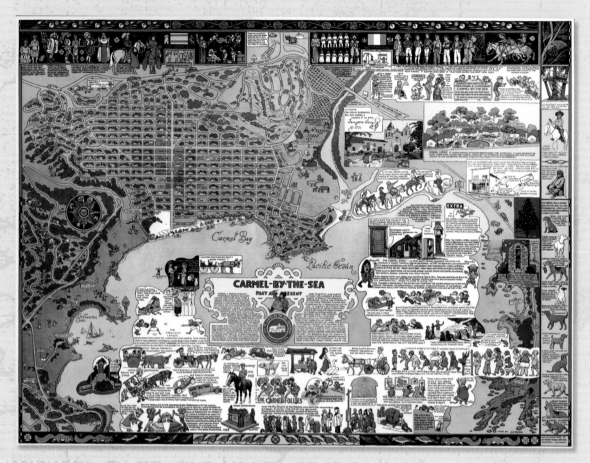

Inspired by . . . *Joseph Jacinto Mora*

Joseph Jacinto "Jo" Mora (1876–1947) was an American cartoonist, artist-historian, sculptor, painter, photographer, illustrator, muralist, author and mapmaker born in Uruguay in 1876. Jo immigrated to the United States as a child, grew and studied in Boston, and then went to work as an illustrator and cartoonist. As a young man, he immigrated to the West, and for two years, lived with the Hopi and Navajo in Arizona. He took photographs, painted and documented the daily life of these Native Americans, particularly the Kachina ceremonial dances. Mora learned the Native languages and made meticulous illustrations of what he was experiencing. In 1907, he moved to the Monterey Peninsula in California, where he spent the rest of his life. Jo was prolific: He practiced nearly every form of art, and often. He has been called the "Renaissance Man of the West."

Jo is probably best known publicly for the series of maps—he referred to them as *cartes*—that he created of the national parks and the landscape and culture of the western United States. This homage to Carmel-By-The-Sea was printed in 1942 and highlights much of the colorful history of the town. His map work is conversational, with bits of writing and pictures floating around the map like cartoon balloons.

1

Draw a map onto watercolor paper. You can use an actual map for reference, or draw it freehand. It doesn't have to be accurate. I drew New Zealand and Tasmania much closer to Australia than they actually are. Compose the map so the elements you plan to include will fit.

2

Paint the map with gouache paints. Use bold, solid colors, such as green and blue, to create a simple background to contrast with the busy illustrations and photos.

3

Outline the map with a black fine-tip permanent marker.

4

Compile pictures and lay them out as desired. Glue them to strips or blocks of paper, leaving a border of color around each photo. Lay them out on the map to ensure they are oriented the way you want, then glue them to the map. Fit them together as you would a puzzle.

5

Measure each area where journaling will be placed. Journal on blocks of paper that will fit in the desired spaces, either by handwriting or by typing. Glue the journaling blocks onto colored paper and trim them, leaving a colored border. Glue them to the map.

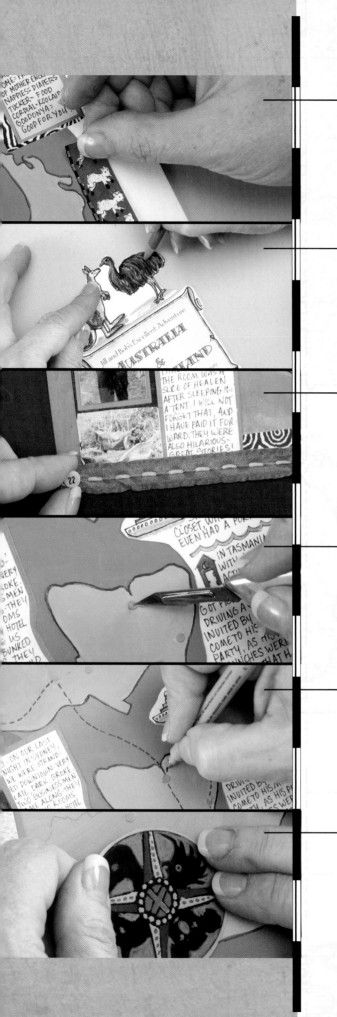

 6

Fill in small empty areas with illustrations, parts of brochures and other ephemera from your trip.

 7

Use clip art or draw a cartouche and add it to the map. I drew an illustration above a clip-art cartouche and added text.

 8

Mount the map onto a piece of mat board. Attach paper strips or ribbon with dashes to the outer edges of the map to suggest neatlines. Use glue or map pins to attach these strips.

 9

Glue punched-out paper dots to the map to mark areas or towns. Paint or draw details, such as topography, landscaping or landmarks, onto the map.

 10

Draw dotted lines to connect the areas or towns, illustrating your journey.

 11

Draw a compass rose, or use clip art, and cut it out. Adhere it to the map.

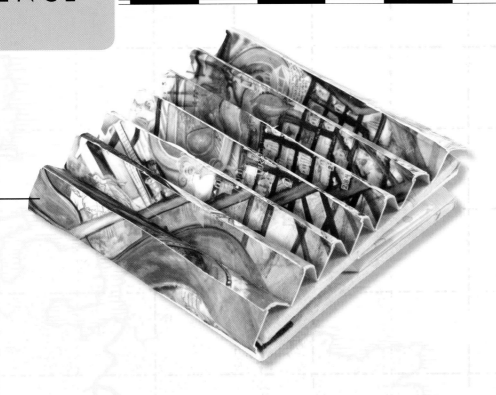

Parallax

Gwen Diehn

I made this collaborative map (actually eighteen copies of it) with a friend who lived in the same exact neighborhood in New Orleans as I grew up in. We didn't know each other until a few months ago, and we lived in New Orleans twenty-five years apart, but we have many memories of this neighborhood that overlap wonderfully. We did our collaboration by each drawing a largish map of the area and mapping the spots that were important to each of us. Then, we designed the book to demonstrate how different people construct different places out of the same space. When the viewer angles the book from side to side, the cover reveals two different maps. Inside is a pop-up map and our two different map keys, again demonstrating the divergent ways in which two people experience the same space.

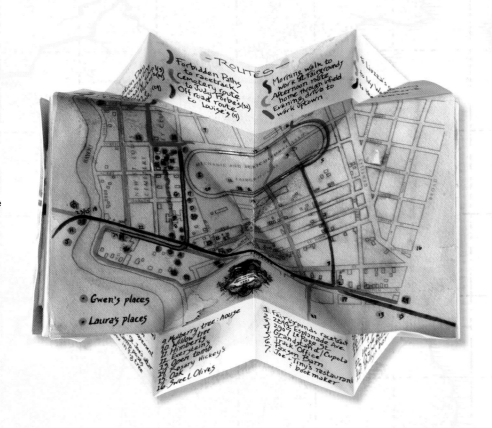

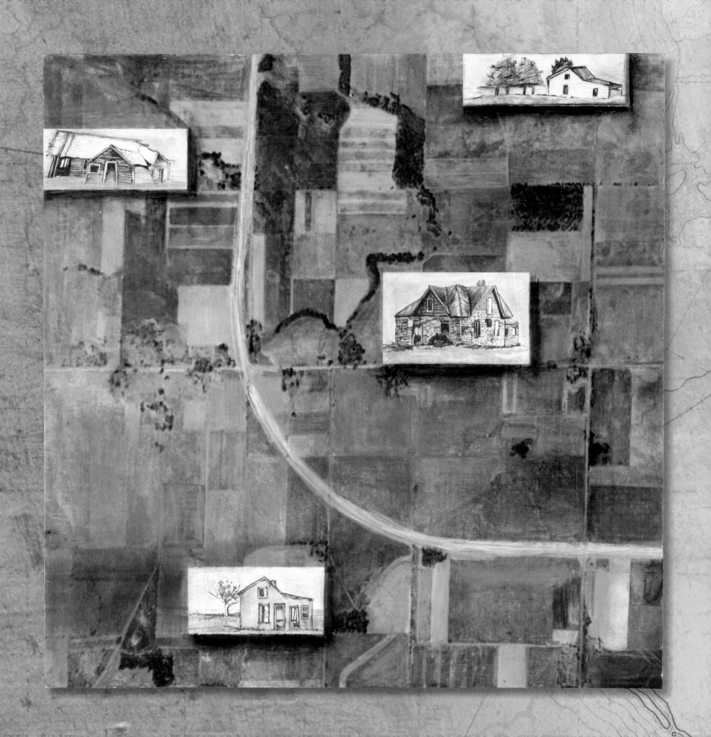

Narrative Map

This map tells a story that needs telling. Is it the journey of your ancestors, or Lewis and Clark? Are you a military family that has moved a lot, or are you in the witness protection program and have to be shuttled around secretly in the night? Do you have a relative that traveled, like my grandmother, to exotic places whenever she could? Is there a place near or dear to you that needs to be explained because it has had a dynamic history or a colorful passage of time? Any story will do here, a tale of before and after, of immigration, romance, illness or that family secret no one talks about. Find a story that you want to explore, and map it out!

MATERIALS AND TOOLS

1—10" × 10" (25cm × 25cm) background map or aerial photo printed on coated laser paper

4–5 pictures of things that illustrate your story: people, things, houses or maps

black crayon

scissors

scrap paper

watercolor crayons

My Map Story

A number of years ago, I moved from Southern California to the foothills of the Rocky Mountains. I was struck by the abrupt and fantastic rise of the mountains running hundreds of miles to the east. My relatives were among the pioneers who traveled by wagon train across the prairie, and they, too, must have been awed at the site of the fourteen-thousand-foot peaks that jutted like giants into the sky. The daunting face of the Rockies halted many pioneers, some of whom tried to make a life here. Scattered across the prairie, sometimes entirely without visible neighbors, are the remnants of the houses that were built by these intrepid explorers.

The prairie houses have a mystique about them that strikes me every time I find one. A great effort was made to haul wood, stone, glass and furnishings for these homesteads. Babies were born, gardens were planted, barns were raised and livestock were penned. Then, at some dark point, these houses were abandoned. Now they sit, decaying in their bones and stories, on the prairies throughout the central United States. The curtains still blow in empty frames, and skeletal remains of furnishings silhouette the windows.

I drew some of the houses in pencil and then cut them out. I then set the prairie houses atop a vintage aerial map of the area, which I colored with exaggerated saturation. I wanted to show the contrast between the very alive landscape and the floating, ghostlike remains of the houses that once brimmed with life and now contain no life at all.

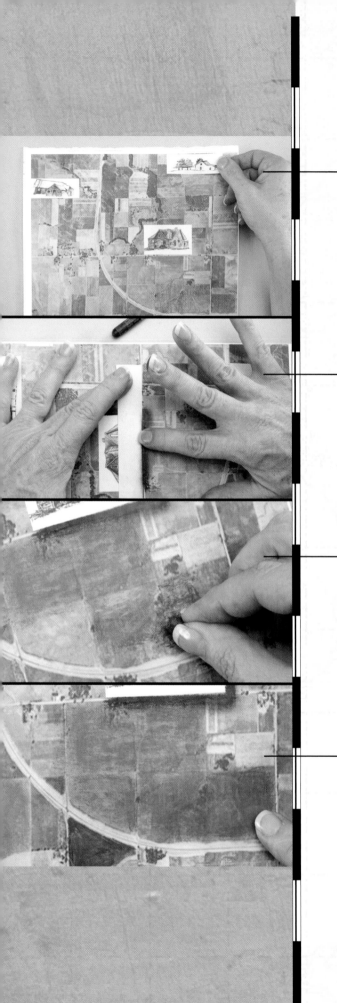

>◦< *1* >◦<

Print a large background map or aerial photo onto coated laser paper. Draw or print images that will be superimposed on this map and cut them out into rectangles. Arrange the images on the map before you glue them down.

>◦< *2* >◦<

Cover the edge of the image with a piece of scrap paper and color along the edge with a black crayon. Repeat this on an adjacent edge to create a drop shadow. Repeat this step for the remaining images, coloring on the same two edges.

>◦< *3* >◦<

Color the background map using watercolor crayons without water. This creates a hand-tinted photo effect.

>◦< *4* >◦<

Rub the colors with your fingers to blend them. The surface will be luminous and shiny.

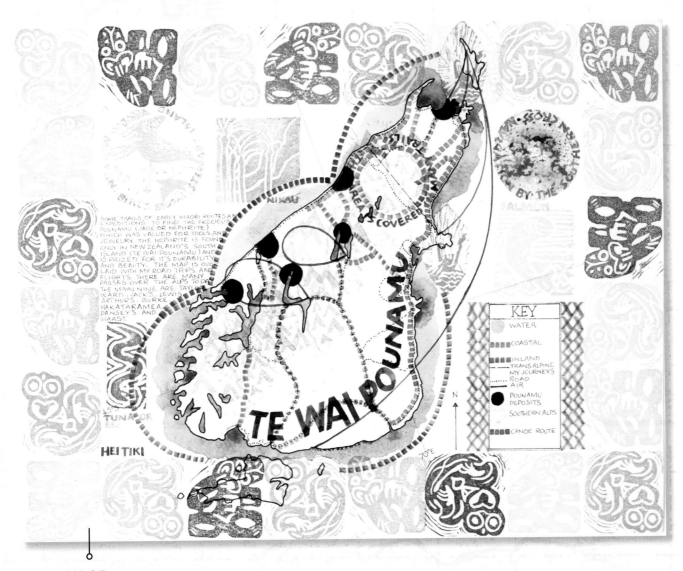

Te Wai Pounamu

Hillary Barnes

The Maori, a people indigenous to New Zealand, valued greenstone (a form of nephrite or jade) for its beauty and strength, making tools, weapons and ceremonial artifacts out of it. They had to struggle against terrain, climate and other marauding tribes to obtain it. Their ancient trails to the rich coastal sources relied on ocean-going and river canoes and difficult treks through mountains. It is thought provoking to walk these beaches today, which are covered in such wealth. The beauty of the area is stunning, and the struggle of the earlier people is all the more amazing with an understanding of history. I wonder if it is a coincidence that my journeys follow many of these early trails. I am always aware of the eerie feeling that others have been here before me.

The Travels of a Cabbie

Gil Avineri

I drive a cab in New York City. Every shift is an anthropologic opportunity to observe, record and empathize with not only my passengers, but the whole of the world around me. The bulk of my profits are saved toward my next long-distance peregrination. Above are some cartographic accounts of these studious journeys and the twelve-hour taxi shifts that facilitate them. I wish to continue learning, mapping and caring for all living things, both by way of work and play.

Dreamer's House

Orly Avineri

If only my house was made of all that I have seen with my own eyes: magnificent
textures and colors, gardens and fountains, courtyards and rooftops.

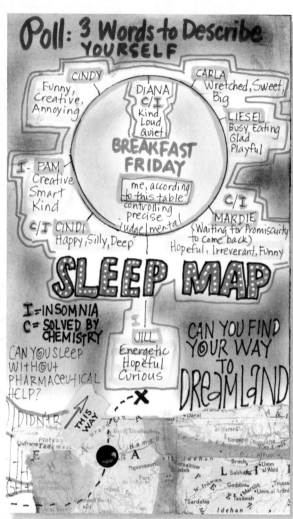

Journal Mapping

Jill K. Berry

I consider myself an explorer, and have a need to know where I am at any given point, so my journals are full of maps. When I go on a trip, it is not uncommon for me to make a map of how I got there. If I eat with a large table full of people, I often make a map of the table, and who sat where.

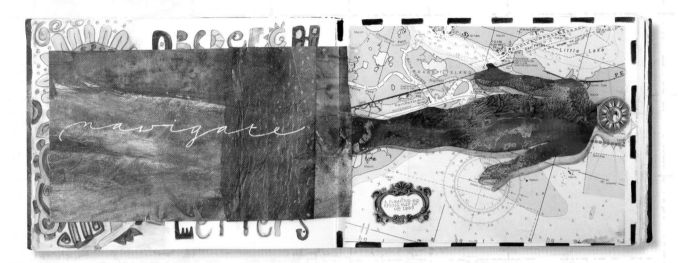

The figure on this spread is made from the template used in the *Body Map* (see page 29). It is cut from painted paper, backed with a vintage map and placed within my journal.

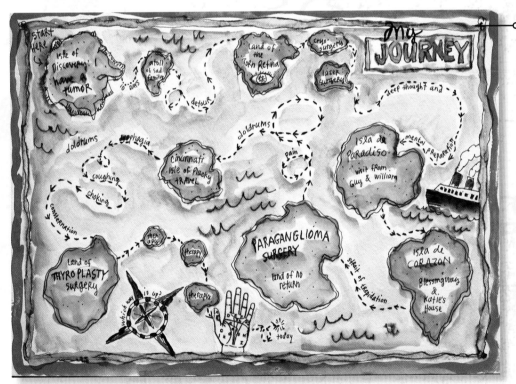

My Journey

Judy Wise

My map is a graphic representation of the experience I had last year after discovering I had a life-threatening tumor in my neck. It felt like I visited many new countries where I'd never been before: telling my family after several weeks of keeping it a secret, then having the complications of eye surgeries and a corrective surgery to restore my voice following the extraction of the tumor. Today, I am back to teaching and living my "normal" life, but I am also forever changed by this journey.

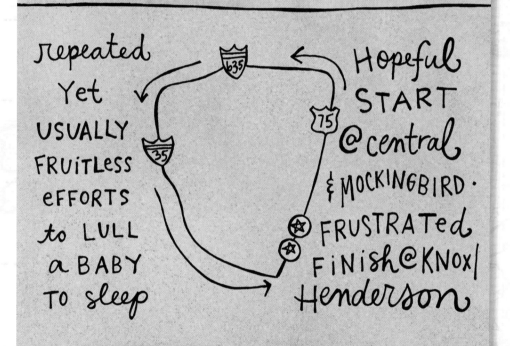

my DAILY drive around DALLAS

repeated Yet USUALLY FRUITLESS efforts to LULL a BABY TO sleep

635

35

Hopeful START @central & MOCKINGBIRD·

FRUSTRATed finish@Knox/ Henderson

25 miles OF STRENGTH· speed · ENDURANCE

No Nap Today

Aimee Dolich

I wasn't willing to accept that my one-year-old was ready to give up the nap, so like a fool, I drove her day after day after day on the same route, hoping for a reprieve.

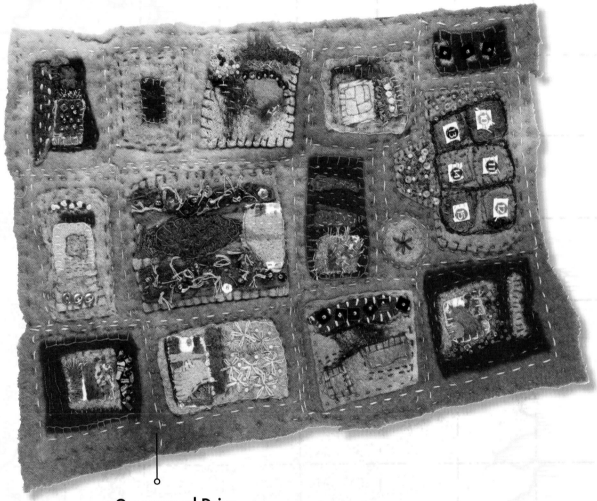

Greenwood Drive

Jane LaFazio

When I was a little girl, I lived on Greenwood Drive. My whole world existed within about five square blocks. My best friend lived down the street, two doors down from the lady who handed out candy all year long, across the street from the mean man who yelled when I rode my bike on his lawn. The next-door neighbor's granddaughter would visit every year, and we'd string up tin-can telephones to talk across the driveway. I would wade in the children's pool, play on the swings and attend birthday picnic parties at Burton Park, a few blocks away. Seems like every day, an ice-cream truck's music alerted me to ask my mom for dimes. Good memories of a life on Greenwood Drive.

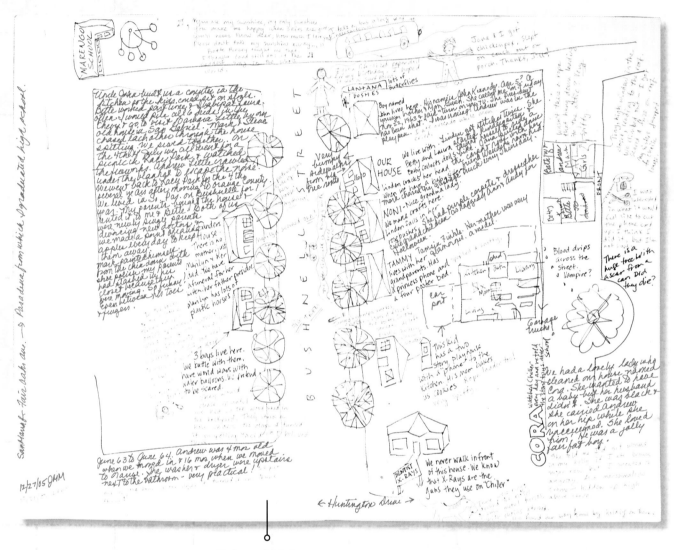

Colored Voices

Jill Berry

The year that my father left is a period of time that stands out not just for me, but for my mother and sister. We lived on a tree-lined street in an old house, surrounded by interesting neighbors. Because this place in time holds such vivid memories for us, I decided to map it.

I drew a map of the neighborhood and wrote in my stories using a black pen. I sent the map to my sister, who added her stories with a blue pen. The map was then sent to my mother, who used a red pen to add hers. Each voice in our shared collaborative map used a different color.

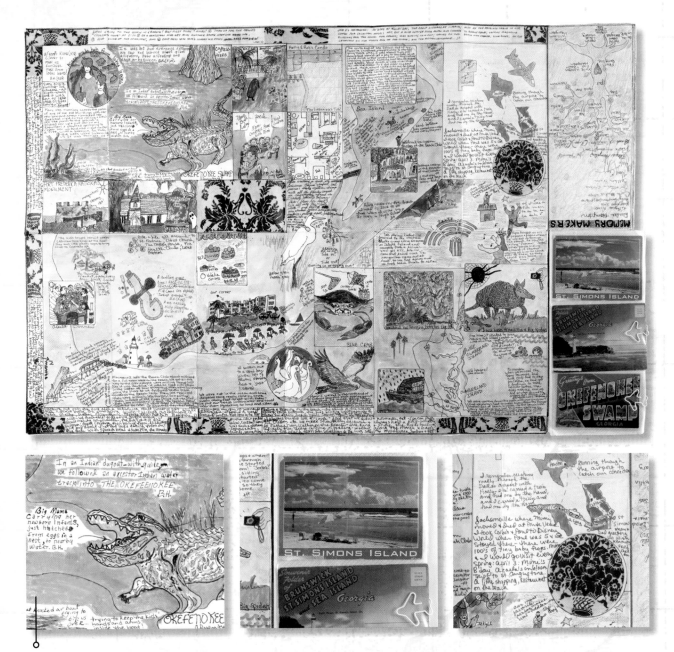

Three Generations of Precious Memories: A Collaborative Map

Deedee Hampton

St. Simon's Island, Georgia holds special significance for our family; my grandfather was stationed there during World War II, and both he and my grandmother retired there. My family has visited there many times since I was thirteen years old, and those visits kept us close. We loved swimming in the ocean, visiting Okefenokee Swamp and eating Georgia peaches. So many precious memories were created there!

My family has not returned to St. Simon's Island since my grandmother died. I asked as many family members as I could to write and draw memories on this collaborative map. They initialed their drawings and journaling to distinguish their different experiences. Creating this map was a meaningful journey: sitting around various dining room tables, chuckling about good memories and getting teary-eyed over some others. Making this map has been a fabulous gift for the whole family.

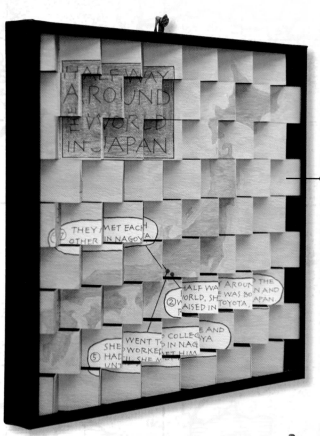

Halfway Around the World

Mitsuko Baum

This piece is about the fate of me and my husband, who grew up halfway around the world from me. Read by alternating the view from side to side, it tells our two stories and how they were joined into one.

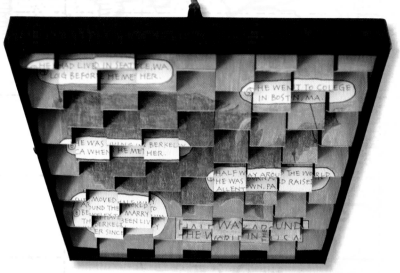

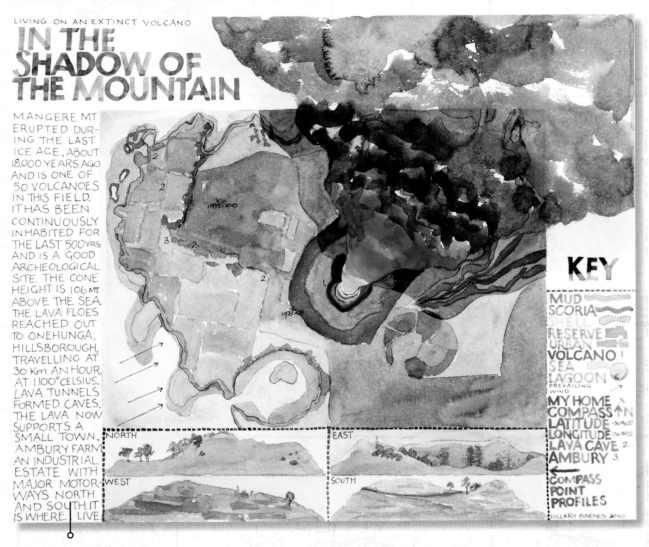

LIVING ON AN EXTINCT VOLCANO

IN THE SHADOW OF THE MOUNTAIN

MANGERE MT ERUPTED DURING THE LAST ICE AGE, ABOUT 18,000 YEARS AGO AND IS ONE OF 50 VOLCANOES IN THIS FIELD. IT HAS BEEN CONTINUOUSLY INHABITED FOR THE LAST 500 YRS AND IS A GOOD ARCHEOLOGICAL SITE. THE CONE HEIGHT IS 106 MT. ABOVE THE SEA. THE LAVA FLOES REACHED OUT TO ONEHUNGA, HILLSBOROUGH, TRAVELLING AT 30 Km AN HOUR, AT 1100° CELSIUS. LAVA TUNNELS FORMED CAVES. THE LAVA NOW SUPPORTS A SMALL TOWN. AMBURY FARM, AN INDUSTRIAL ESTATE WITH MAJOR MOTORWAYS NORTH AND SOUTH. IT IS WHERE I LIVE.

KEY

MUD
SCORIA
SHELL
RESERVE
URBAN
VOLCANO 1
SEA
LAGOON
PREVAILING WIND 7
MY HOME X
COMPASS N
LATITUDE -36.9637
LONGITUDE 174.8072
LAVA CAVE 2
AMBURY 3
COMPASS POINT PROFILES

NORTH
EAST
WEST
SOUTH

HILLARY BARNES 2010

Under the Volcano

Hillary Barnes

For the last forty years, I thought I lived in an ordinary place. Yes, there are extinct volcanoes all around me and escape routes would come to me as I drifted off to sleep, but it's just a regular suburb with neighbors, potholes and rubbish strikes. Wouldn't you think that ordinary? It's only when a volcano erupts that you might question the stupidity of living there.

"Hau Mangere" ("lazy winds") erupted during the last ice age, about eighteen-thousand years ago, and is one of fifty volcanoes in this field. It has been inhabited continuously for the last five-hundred years by the Maori and is a valuable archeological site because it is one of the least modified cones in the Auckland city area. The height of the highest cone is one-hundred and six meters above sea level, and, when it erupted, it created the lava flows that continued to the sea and now support urban housing and farmland. There are twelve known lava caves on Ambury farm. Most have access denied.

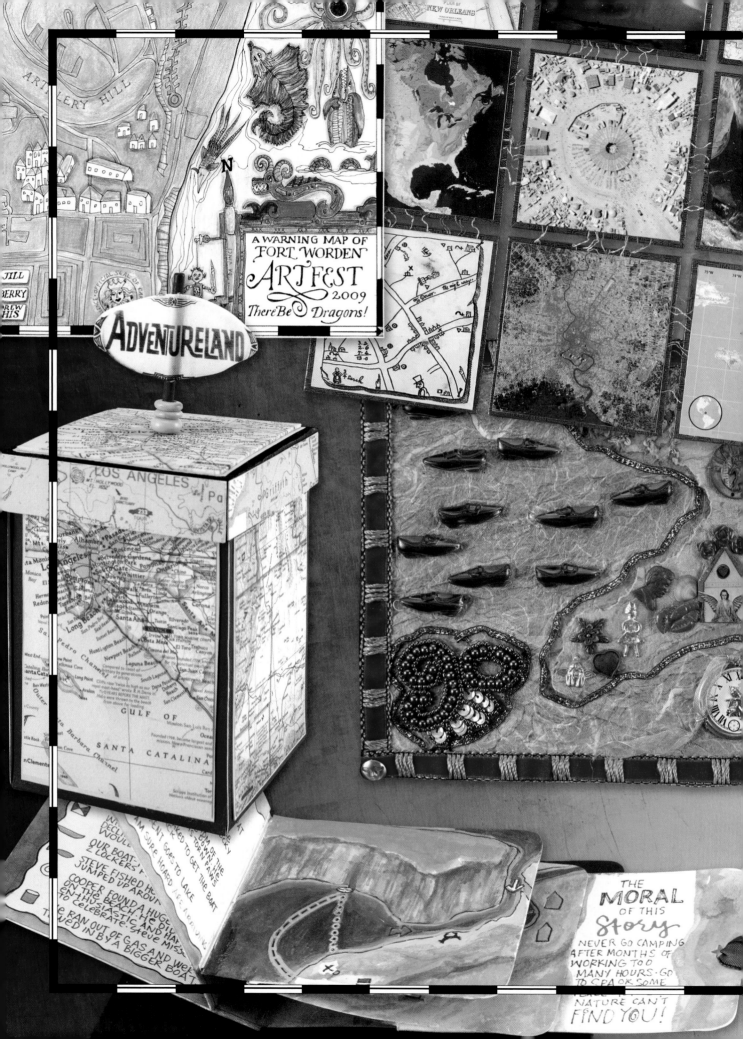

"A place for everything, everything in its place."
—Benjamin Franklin

CHAPTER 3
Plans, Projections and Possibilities

This chapter is about creating mixed-media art pieces from real or fictional maps. We will also use postcards, travel souvenirs and various ephemera to make books, boxes, maps and journals.

When I travel, I gather lots of fodder: postcards, maps and brochures. I simply can't throw these things away, so you can imagine my piles of travel goodies. And, since I teach a mapping class, people give me lots of maps. There is a big box in my studio containing all the cartographic ephemera that were the inspiration for this section of the book.

In this chapter, you can make a flipping book, a postcard journal of a vacation and a map of your future. You will create a map of the perfect place and one about something you cherish.

This is also a chance for storytelling. In the *Postcard Journal* (see page 120), I included a story about my grandmother, since my vintage postcards from Paris were blank. Nana was a fascinating woman, and I sat with the idea of her for a while and then wrote the journal I thought she might have written in 1953 on her trip to Paris with my grandfather.

I also worked on black paper, which harkens back to my youth, wandering the streets of Tijuana, Mexico, south of my home in Southern California. Aside from the "zonkeys" (donkeys painted like zebras, hitched to wagons you could sit in for a photo, wearing a giant sombrero), the part I loved best was the black velvet paintings; in other words, Velvet Elvis. This is my tribute to all the Mexican artists who hung religious and secular paintings up in those canvas street galleries.

A map or cartographic piece is another perfect place to pull out your artistic license and use it. Remember that your maps, like the maps of those who came before you, are exercises in personal expression. You are in charge of the truth and imagination in them, and of every single thing you decide to place on them.

Explore, dream, wonder and begin!

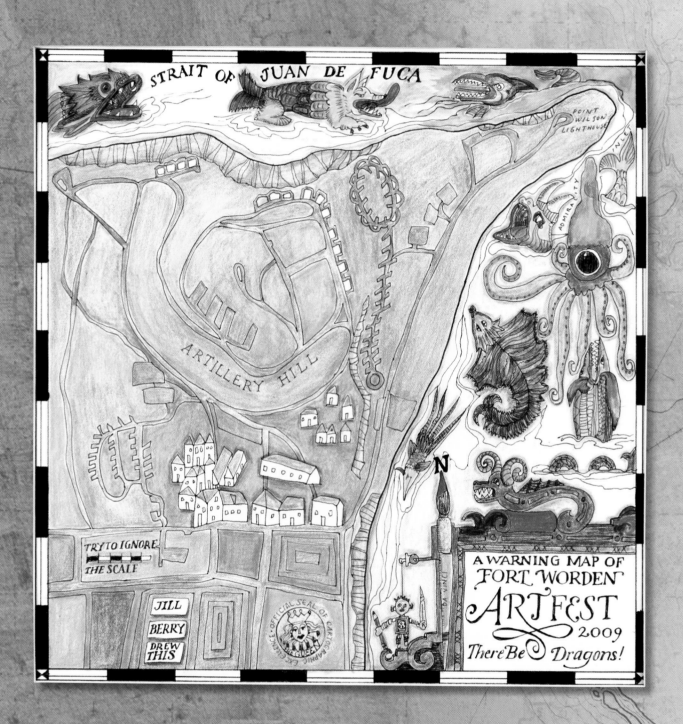

STRAIT OF JUAN DE FUCA

POINT WILSON LIGHTHOUSE

ADMIRALTY INLET

ARTILLERY HILL

N

TRY TO IGNORE
THE SCALE

JILL
BERRY
DREW
THIS

OFFICIAL SEAL OF CARTOGRAPHIC EXCELLENCE

A WARNING MAP OF
FORT WORDEN
ARTFEST
2009
There Be Dragons!

Fictional or Channeled Maps

Create a map of a fictional place from a book you have read, or a real place channeled by a fictional character, or a combination of both.

My Map Story

A few years ago, I attended an art retreat that had the theme of sea monsters. It was held at an old army base that once guarded the nautical entrance to Puget Sound, a romantic place with a rich history of tall ships and sailor stories. It was obvious to me that sea monsters were lurking there, and I felt compelled to share this with the attendees. I made about one hundred pop-up maps and handed them out.

MATERIALS AND TOOLS

1—11½" × 11½" (29cm × 29cm) piece of hot press watercolor paper

black fine-tip permanent marker

colored pencils

pencil

reference map

reference sea monster images or clip-art sea monster images

Inspired by . . . Books with Endpaper Maps

For years, publishers printed maps onto the endpapers in children's books to illustrate the narratives of the books. Maps appeared in the opening pages of *The Wizard of Oz*, *The Wind in the Willows* and other classic books by both American and British authors. What an invitation to adventure! Books containing maps were a guaranteed read for me as a kid.

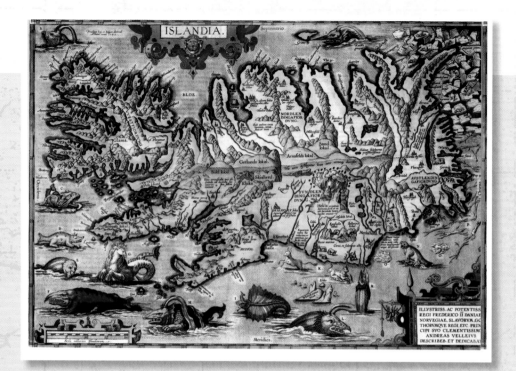

Inspired by . . . *Abraham Ortelius*

The map I used as a resource is *Islandia*, attributed to Abraham Ortelius (1609). He was inspired by the work of a guy named Munster, who, in the landmark work *Cosmographia*, drew a chart of sea and land creatures (1545). The combined works of these two provide spectacular imagery of sea monsters in the Age of Discovery, and continue to make a splash among admirers of this genre.

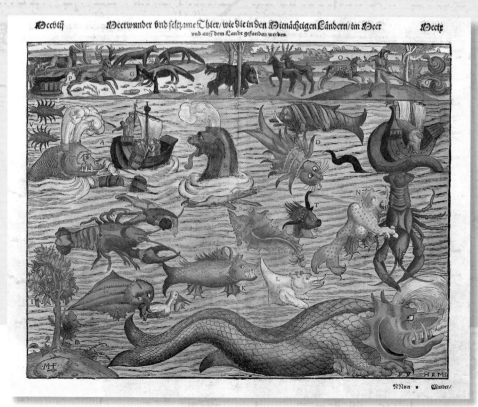

➤➤ *1* ➤➤

Use a real map as a reference to draw your map onto a piece of watercolor paper. You may also photocopy or print a map directly onto the paper. If you draw the map, outline it with a black fine-tip permanent marker.

➤➤ *2* ➤➤

Sketch sea monsters or cut out and glue clip-art monsters onto the map. I used Abraham Ortelius' *Islandia* map and sea-monster chart as inspiration (see facing page).

➤➤ *3* ➤➤

Add neatlines, a cartouche, a legend, a scale and other elements to your map with a black fine-tip permanent marker. Again, I used Ortelius' map as a launching pad for the cartouche I drew.

➤➤ *4* ➤➤

Give yourself the seal of approval. It's a feel-good thing!

➤➤ *5* ➤➤

Highlight the sea monsters, coast and other images in or on the water with a blue colored pencil to add a drop shadow and depth.

➤➤ *6* ➤➤

Color the map with colored pencils to show the topography and energize the map.

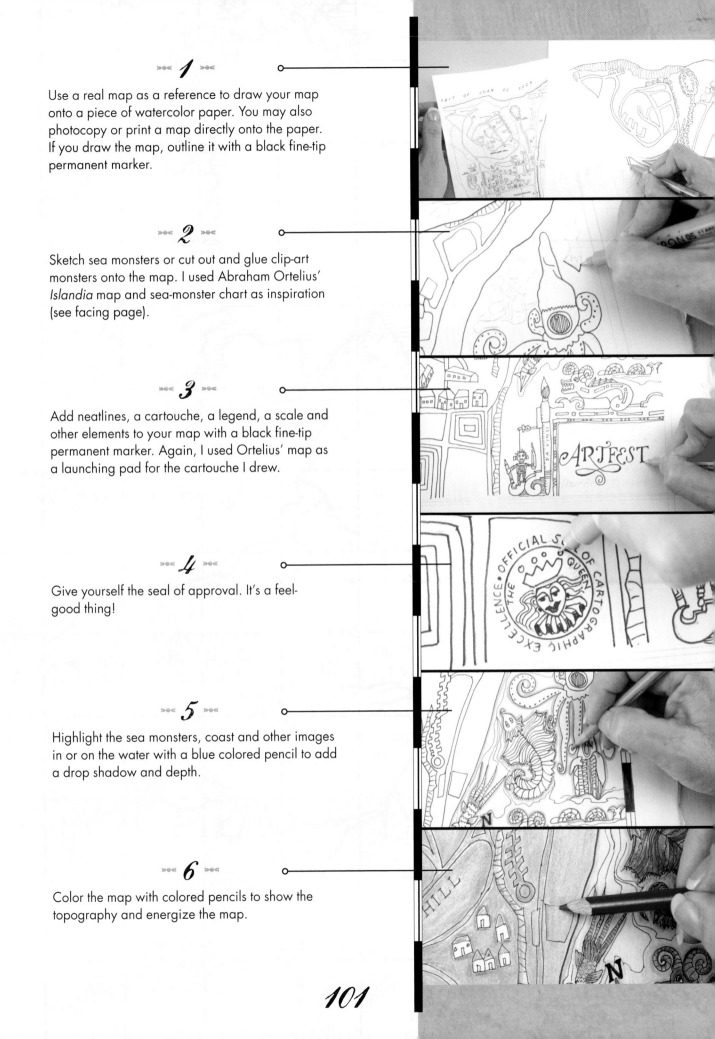

Realm of the Sea Dragon

After watching a nature show on sea dragons, I found out that the only place these charming feathery creatures live is the southern coast of Australia, around Tasmania, and slightly up the sides of the continent. The sea dragon has all sorts of iridescent appendages, making it the perfect subject for a map like this.

Working on black paper is a technique that also lends itself to collage. Work on the same paper, leaving black shapes and borders.

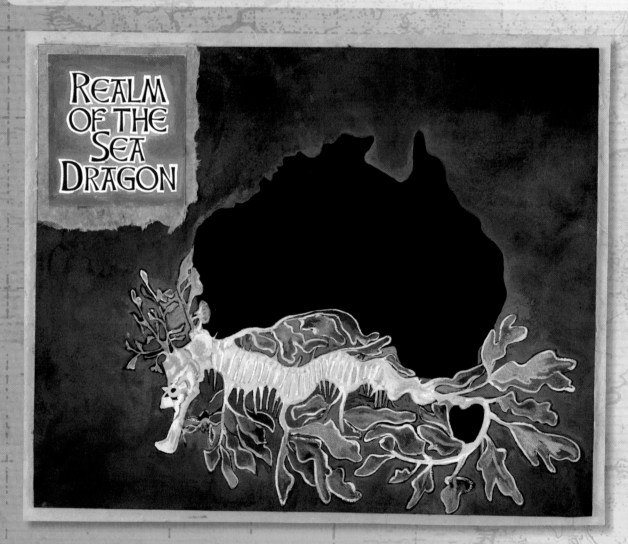

MATERIALS AND TOOLS

- 1—3" × 3" (8cm × 8cm) piece of watercolor paper

- 1—3½" × 3½" (9cm × 9cm) piece of contrasting colored paper

- 1—8" × 10" (20cm × 25cm) piece of soft black paper

- 1—8½" × 10½" (21.5cm × 27cm) piece of mat board

- gouache paints

- hard pencil

- iridescent watercolors

- opaque paints

- paintbrushes

- palette

- printer

- reference images of the maps and imagery you want to use

- white soft lead colored pencil

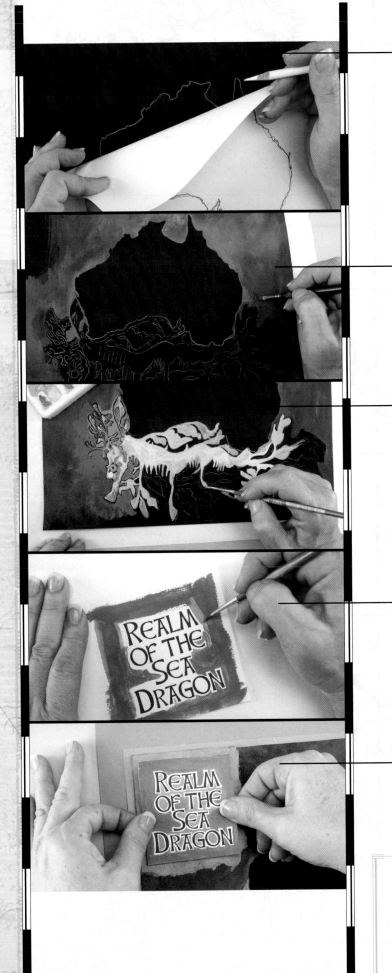

1

Shade over the outline of a map using a soft white colored pencil. Place the shaded side down on a piece of black paper. Using a hard pencil, trace over the outline of the map to transfer it to the black paper. Transfer any other imagery—in this case, a sea dragon—in the same way.

2

Fill in the background with gouache paints. Paint thinly so the black shows through.

3

Paint the sea dragon using opaque paints, leaving a thin margin of black between the background and the subject. This thin line of black makes the colors pop and adds depth to this technique. Add a layer of iridescent watercolors for shimmer.

4

Print out the title onto watercolor paper. Paint around the words using watercolors and a fine-tip paintbrush. Let it dry.

5

Mount the piece on contrasting paper and then on mat board. Mount the title in the upper left corner.

Tip

Use a black eraser to remove white pencil lines. It will leave no residue when erasing on black paper.

An Unfolding Maze of His Future
as of August, 2010

During my last year in college, I attended a lecture presented by a motivational speaker. It was atypical for me to take the time to do this, but he was so dynamic and electrifying that I couldn't leave the room. He said he was far more afraid of what he would not do in his life than what he would do. He did not want to have five minutes on his deathbed to think about what he had missed because of fear or laziness. I went home that day and made a life-goal list. This project is about that list, and how a part of it might relate to places.

Make a list of nine places you would like to see, or things you would like to do, before you die. They can be specific or abstract. They can also be event-related, as is the case with the one I created. The maze book you create will have maps on one side of each section and place names on the other. The maps will unfold to reveal a total picture of your future.

MATERIALS AND TOOLS

- 1—4" × 13" (10cm × 33cm) piece of mulberry paper
- 1—4" × 16½" (10cm × 42cm) piece of mulberry paper
- 1 seed bead
- 3 colors of rayon embroidery floss
- 9—4" × 4" (10cm × 10cm) pieces of .78 binder's board
- 9—4¾" × 4¾" (12cm × 12cm) pieces of decorative backing paper
- 9—3¾" × 3¾" (9.5cm × 9.5cm) maps or images that represent your nine to-do's
- 30" (76cm) of ribbon
- clip-art or drawn compass rose on cardstock
- craft knife
- cutting mat
- decorative paper for labels
- glue brush
- linen thread
- printer
- scissors
- sewing needle
- white glue or other tacky glue

My Map Story

I interviewed my husband Steve for this project and asked him for his nine to-do's.
1. Attend Burning Man, a social activist event in the Nevada desert.
2. Participate in a reparation effort, such as Haiti earthquake relief.
3. Attend a world party like Mardi Gras or Solstice.
4. Visit Thailand.
5. Go on tour with his band.
6. Sail in the Bahamas.
7. See the Northern Lights.
8. Make an interstate "hobo walk."
9. Canoe the Boundary Waters in Minnesota.

go on an African safari
live on the beach - anywhere
visit Spain and Portugal
cruise the Galapagos
visit Alaska - see a grizzly
wander around Idaho
do a walking tour in England
visit the family castle in Scotland
tour Thailand
teach in San Miguel de Allende
visit friends in Australia
live a summer in Ireland

Inspired by . . .
My Life-Goal List

In college, I made a list of all the things I wanted to do in my life. That list of dreams, goals and desires has kept me motivated for a long time.

1

Glue a 4¾" (12cm) square of backing paper to one side of a 4" (10cm) square of binder's board, centering each piece. Miter the corners of the backing paper to reduce bulk: Place a scrap piece of binder's board at a 45-degree angle against the corner of the board and use a craft knife to trim the backing paper beyond it.

2

Apply glue to the edge of the board and the flap of backing paper. Roll the edge of the board onto the paper edge. This pushes out air bubbles and makes a smooth edge. Repeat this step on the opposite edge of the board.

3

On one of the remaining unfolded flaps, pinch the triangular corners in, tucking them in toward the center and flattening them onto the board edge. Apply glue to the edge and the flap and roll the board onto the flap as in Step 2. Repeat Steps 1–3 for all nine board squares.

4

Lay out your chosen nine maps or images and arrange them until they are in a pleasing order in a 3 × 3 grid.

5

Use the illustration on page 108 as a guide to connect the binder's board grid together with separated strands of embroidery floss.

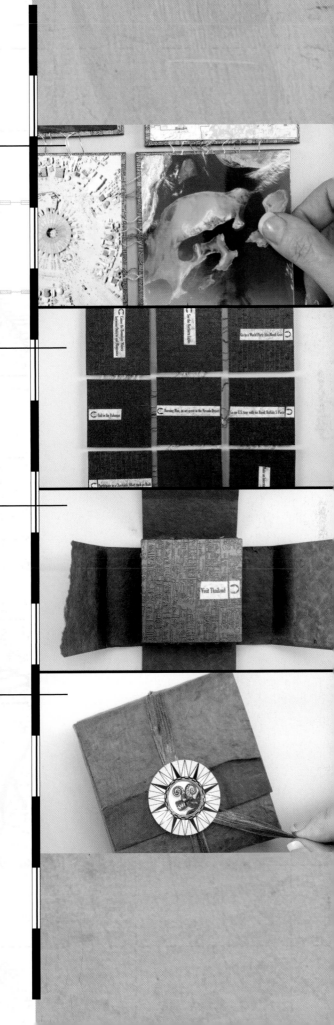

6

Glue the maps or images on top of the floss.

Tip

The embroidery floss strands need to be both thin and strong so you won't see or feel them beneath the maps.

7

Print labels for each of the maps or images onto decorative paper. Cut each label out and glue it to the back of the maze, accompanying each label with an arrow. Refer to the illustration on page 108 for the placement of the labels and arrows.

8

See the instructions on page 108 to fold the maze. Make a wrapper for the maze using two pieces of mulberry paper. Center the folded maze on top of the shorter piece of mulberry paper and wrap it. Fold in one shorter edge of the other piece of mulberry paper 1" (2.5cm). Place the maze on this piece, 4½" (11.5cm) from the folded edge. Wrap the remaining two sides of the maze.

9

Draw or print out a compass rose and color it. Attach it to the top flap of the wrapper with linen thread and a needle. Sew up through the cover and the center of the compass rose. Thread a seed bead onto the needle. Sew back down through the compass rose and the cover flap, positioning the needle in a slightly different place. Fold a 30" (76cm) piece of ribbon in half and loop the center beneath the compass rose. Wrap the ribbon around the entire piece. Secure the ribbon ends by wrapping them several times around the compass rose.

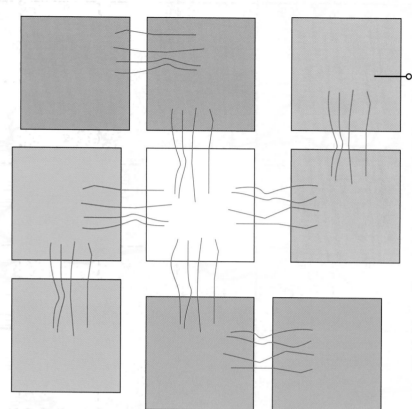

Assembly

Notice the pairs of boards. Two boards are joined to each other ½" (1.3cm) apart, then one of them is joined to the center board. The embroidery strands that connect the pairs of boards to the center board become progressively longer to allow room for stacking.

Folding the Maze

To fold the maze up, first fold each pair of boards so their right sides are facing each other. Then, fold the pair with the shortest embroidery strands in toward the center board. Continue folding each pair in toward the center, working from shortest embroidery strands to longest.

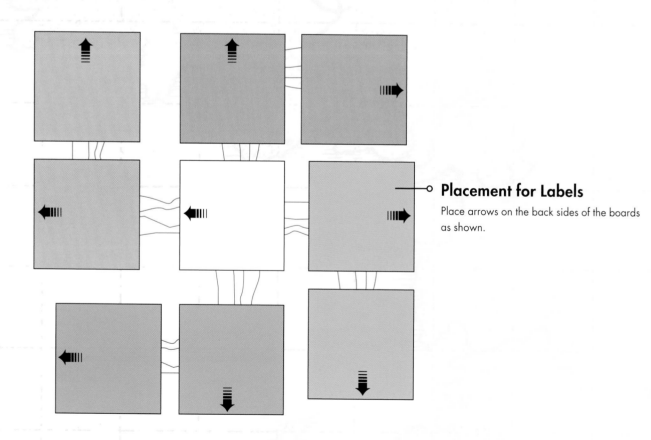

Placement for Labels

Place arrows on the back sides of the boards as shown.

SOMe peregrinations ACROSS the NATIONS that I'd like TO make

I'VE never BEEN to FARGO AND THAT CHAPS MY GYPSY hide

ALASKA to SEE iCeBeRgs & other STUFF

Istanbul ...·: NOT :·... CONSTANTINOPLE

first TO MeDELLÍN colombia. THeN to See the OBJeTOS perdidos at ANDRÉS carne De Res Near BOGOTÁ

TOKYO to GO PROWLING iN the STATIONERY SHOPS & buy LoTS of TCHOTCHKes

Yalta TO see WHeRe STYOPA MATeRIALIZED in the MASTer AND MARGARITA

Montréal I've BEEN TO THe AIRPORT · does THAT COUNT MON Dieu · NON

PeLLa IOWA tulip FeSTIVAL I Keep MiSSing it

MYSTERY SHOW UP @ the AIRPORT W/ BAG and PASSPORT and TAKe it FROM THeRE ? ? ? ? ? ?

Peregrinations

Aimee Dolich

I'd love to go to many more than nine places—the list continues!

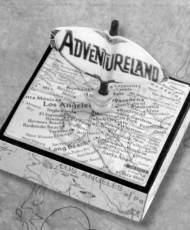

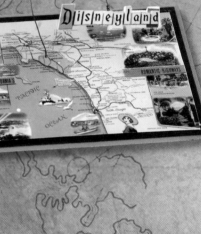

Cartographic Reliquary

A cartographic reliquary is a container meant to hold something precious to you that has to do with a place. The container is made from postcards and maps that represent this place. Using four postcards and a map, you will cover the inside and outside of the box. Add the relics in the center and some pop-up elements on wire for extra zing, and you will have a mixed-media monument to something you wish to remember in a whimsical way.

My Map Story

My project features two plastic toy figurines of a cowboy and an Indian from my childhood (the relics) and postcards and maps of Southern California, where I grew up. Amusement parks sprang up around me in every direction, with themes of oceans, cowboys and movies, all frontiers to be explored in California in the 1960s.

Cecil In-The-Music Box

TRADING TOYS CARDS

Inspired by . . .
Jack-in-the-Box

Beanie and Cecil was my favorite cartoon as a youngster, (foretelling my penchant for sea monsters). Beanie was this hardy cute kid with a helicopter hat that was always in trouble with kidnappers and the like. Cecil was his sea-serpent friend, who launched into each rescue yelling, "I'm a-comin', Beanie-boy!" This trading card shows a toy music box that plays the theme from the show. At one surprising turn of the handle, Cecil pops out.

MATERIALS AND TOOLS

1—4" × 4¾" (10cm × 12cm) map, laminated on tag board and cut into 4 strips measuring 1" × 4¾" (2.5cm × 12cm) (lid)

1—4¼" × 4¼" (11cm × 11cm) map (lid)

1—4½" × 4½" (11.5cm × 11.5cm) map, laminated on cover weight paper (box)

1—4½" × 4½" (11.5cm × 11.5cm) piece of tag board (lid)

1—6¾" × 6¾" (17cm × 17cm) piece of cover weight paper (lid)

1—17½" × 17½" (44.5cm × 44.5cm) piece of white cover weight paper (box)

1 map, cut to 4 vertical pieces, measuring 4" × 6" (10cm × 15cm) each (box)

1 title sign printed onto cover weight paper

2 relics from your childhood

3 flat wooden beads with ⅛" (3mm) holes

3" (8cm) wooden dowel with ⅛" (3mm) diameter

4—4" × 6" (10cm × 15cm) postcards (box)

4—4¼" × 6¼" (11cm × 16cm) pieces of black mat board (box)

4—4¼" × 6¼" (11cm × 16cm) pieces of tag board (box)

5 location signs printed onto cover weight paper

16-gauge craft wire

awl

cover weight paper for backs of signs

craft glue

craft paint in two complementary colors

Japanese hole punch

mandrel

paintbrush

scissors

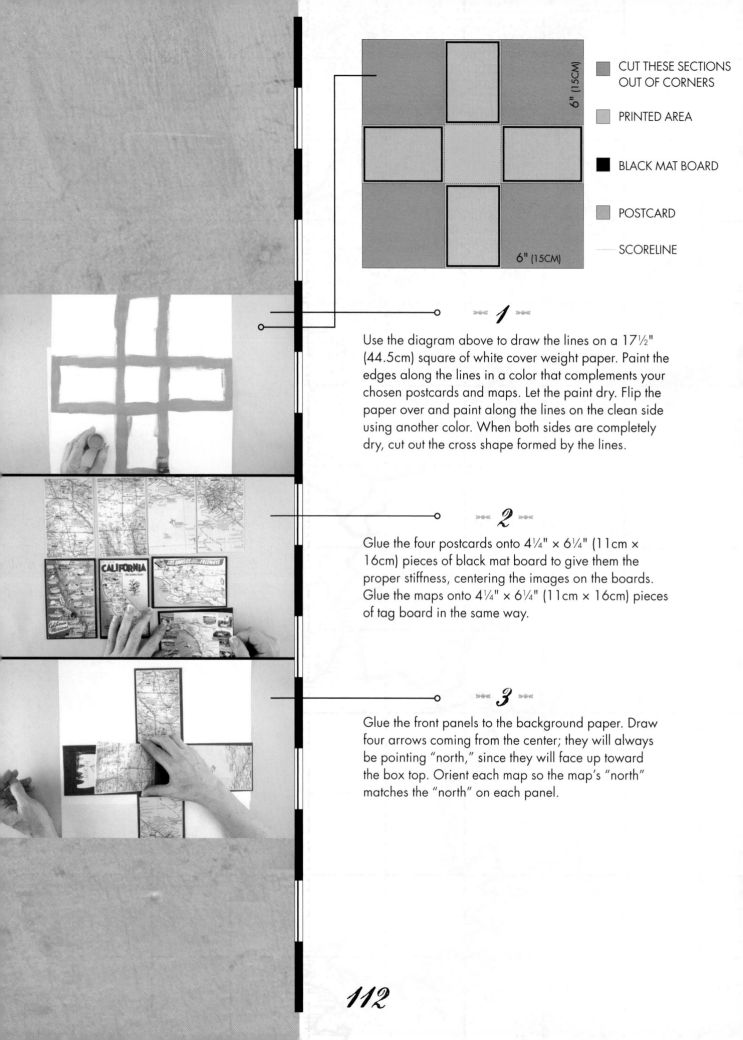

6" (15CM)

CUT THESE SECTIONS
OUT OF CORNERS

PRINTED AREA

BLACK MAT BOARD

POSTCARD

········· SCORELINE

6" (15CM)

➤❮ *1* ➤❮

Use the diagram above to draw the lines on a 17½"
(44.5cm) square of white cover weight paper. Paint the
edges along the lines in a color that complements your
chosen postcards and maps. Let the paint dry. Flip the
paper over and paint along the lines on the clean side
using another color. When both sides are completely
dry, cut out the cross shape formed by the lines.

➤❮ *2* ➤❮

Glue the four postcards onto 4¼" × 6¼" (11cm ×
16cm) pieces of black mat board to give them the
proper stiffness, centering the images on the boards.
Glue the maps onto 4¼" × 6¼" (11cm × 16cm) pieces
of tag board in the same way.

➤❮ *3* ➤❮

Glue the front panels to the background paper. Draw
four arrows coming from the center; they will always
be pointing "north," since they will face up toward
the box top. Orient each map so the map's "north"
matches the "north" on each panel.

112

4

Flip the piece over. When you flip it, the front of the box needs to be facing you.

5

Cut out signs and an accompanying piece of cover weight paper to serve as a backing. Mount each sign onto a 3"–4" (8cm–10cm) piece of craft wire, sandwiching the wire between the sign and its backing piece. Use a mandrel to make loops in some of the wires.

6

Using an awl, punch a hole in each postcard panel to accommodate a wire sign. Make the hole small so the wire fits snugly within it. Insert the sign pole. Bend the wire flush to the bottom of the panel.

7

When the reliquary is closed, the wires should not tangle. For the next sign, place the postcards adjacent to each other, as they would be when the box is closed. Judge how high the wire should be based on the other sign's position. When height is finalized, bend the wire flush to the bottom of the panel. Repeat Steps 6 and 7 with the remaining signs.

8

For each sign, apply craft glue to both sides of the wire on the underside of the panel to keep the wire from moving. Mount the postcard panels and the center map panel to the inside of the reliquary. Adjust the position of the signs before the glue dries.

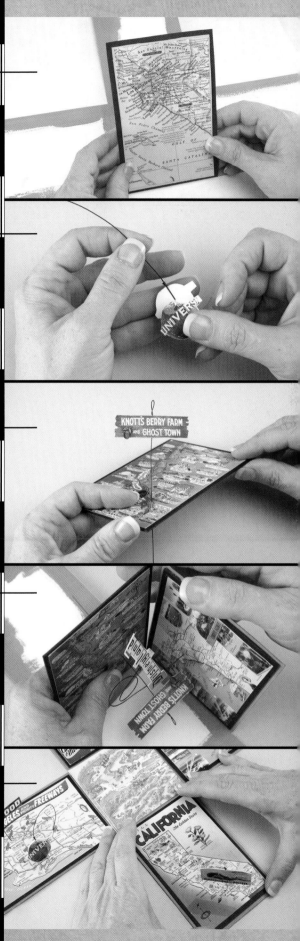

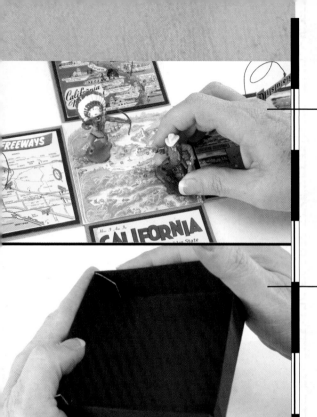

9

Attach the relics to the center panel with glue dots.

10

Use the template on the next page to cut out the reliquary lid from cardstock. Fold in the tabs and glue them to secure the corners on the inside of the lid.

11

Print a title sign onto cardstock. Cut out both the title sign and a backing piece. Sandwich a ⅛" × 3" (3mm × 8cm) dowel between the sign and the backing paper and glue them together.

12

Glue a 4¼" × 4¼" (11cm × 11cm) map onto a 4½" × 4½" (11.5cm × 11.5cm) piece of tag board. Turn the panel over and mark the center. Use a Japanese hole punch to make a hole in the center of the panel.

13

Glue four 1" × 4¾" (2.5cm × 12cm) map panels to the sides of the reliquary lid.

14

Glue the tag board map panel to the top of the lid. Slide three flat wooden beads onto the dowel. Glue the dowel into the hole in the map panel.

TEMPLATE FOR BOX TOP
Actual size

———————— CUTTING LINE

- - - - - - - - SCORING LINE

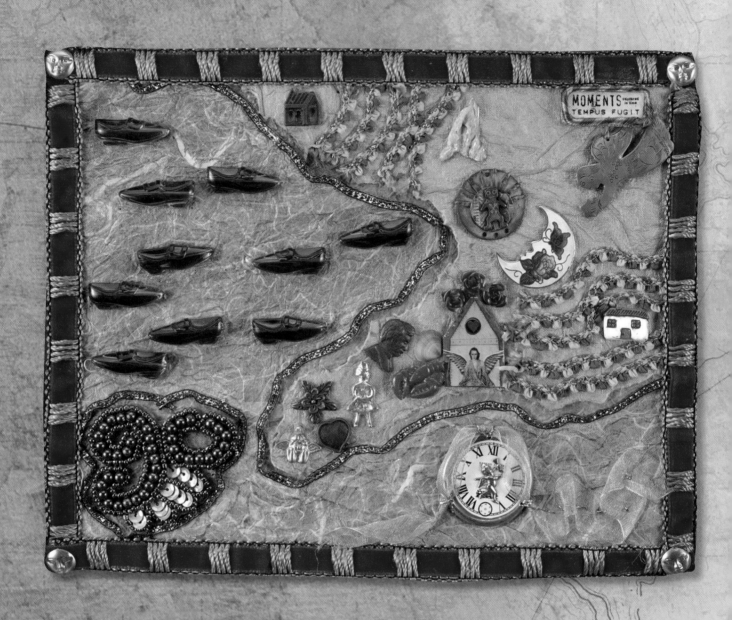

Utopian Topography

For this project, you will make a map of a place you consider ideal or perfect. You will create a mixed-media representation of that place. Write a list of elements that belong in your Utopia and gather materials to represent those things.

My Map Story

While hiking and walking the small towns of the Amalfi coast in Italy, I felt that I had found Utopia. It was a brilliant blue day, and I was traveling alone. The natives were gorgeous and friendly, and the landscape sparkled. The fragrance of the blooming flowers mixed with the scent of the sea. In a small café near the sand, I savored the best *pasta al mare* in memory, and I could see the Cathedral of Santa Maria Assunta with its majolica-tile dome from my table. At dinner that night, a group of Italians across the restaurant from me were so impressed with my Italian that they paid for my dinner. The entire experience was dreamlike, from beginning to end, and I actually felt shivery with glee.

My map contains symbols of those events and places, but mostly it represents how I felt being there. I used red velvet ribbon for the neatlines, placed blue shoe beads (Italy is all about the shoes) in the bright blue Mediterranean, and sewed on a section of beaded trim for the Isle of Capri. I designed this piece to fit inside a gold Italianate frame that I found at a thrift store.

MATERIALS AND TOOLS

1—8" × 10" (20cm × 25cm) picture frame

1—8" × 10" (20cm × 25cm) piece of turquoise unryu paper

1—8" × 10" (20cm × 25cm) piece of gold unryu paper

beaded embellishment

blue iridescent ribbon

blue metallic ribbon

charms, including one that resembles a compass rose

floral ribbon trim

metallic thread

reference map

sewing needle

striped ribbon

white glue

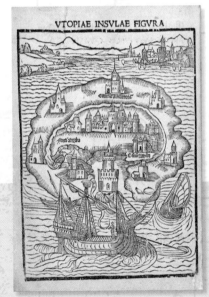

VTOPIAE INSVLAE FIGVRA

Inspired by . . .
Sir Thomas More

The word *utopia* was invented by Sir Thomas More, for his 1516 book of the same name, to describe the perfect society on an imaginary island. The word is now used to describe any imaginary place that is considered ideal or perfect.

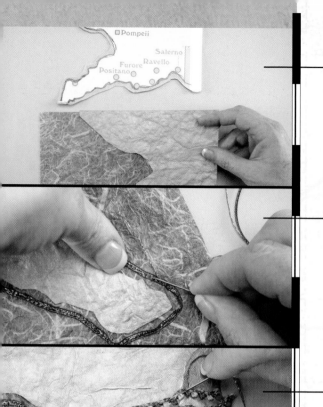

1

Use a map as a reference, or cut an imaginary land mass from gold unryu paper. Glue the land mass to an 8" × 10" (20cm × 25cm) piece of turquoise unryu paper.

2

Add an embellishment that resembles an island. Mine is a beaded trim from a fancy dress. Sew a running stitch along the shoreline of the coast with metallic thread, attaching the blue metallic ribbon to the background paper.

3

Place a house charm on the land mass. Sew floral ribbon trim around the house using metallic thread.

4

Sew a compass rose—in this case, a clock earring—onto the map. Sew pale-blue iridescent ribbon and blue shoe beads onto the turquoise paper to mimic the ocean.

5

Glue or stitch other charms that represent elements you would like in your Utopia.

6

Fit the piece in a frame with a backing. Glue striped ribbon along the edges of the piece for neatlines.

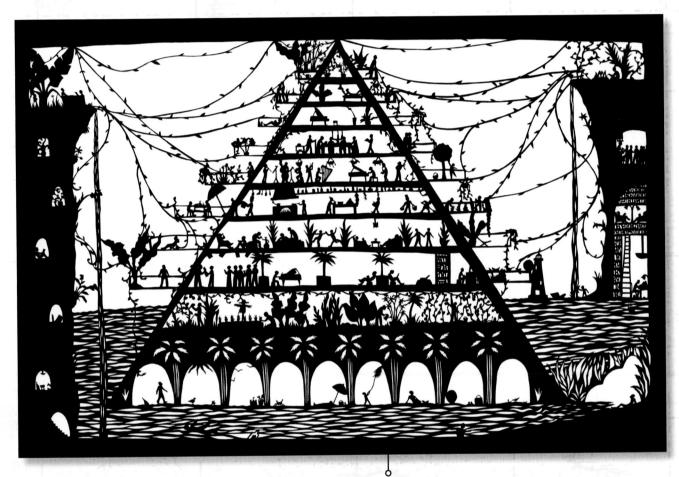

Personal Cities

Béatrice Coron

"Personal Cities," also called "Freudian Cities," began with the idea of imagining a city that would contain all the essential elements of one single person's life. The person needs to describe, in words, the kind of city she would like to call home. I then make a paper-cut image of the person's wishes and memories. It is a mental map to find your own stories and make sense of an individual's experiences.

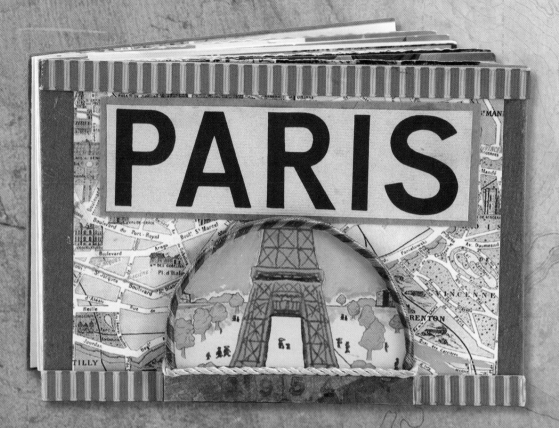

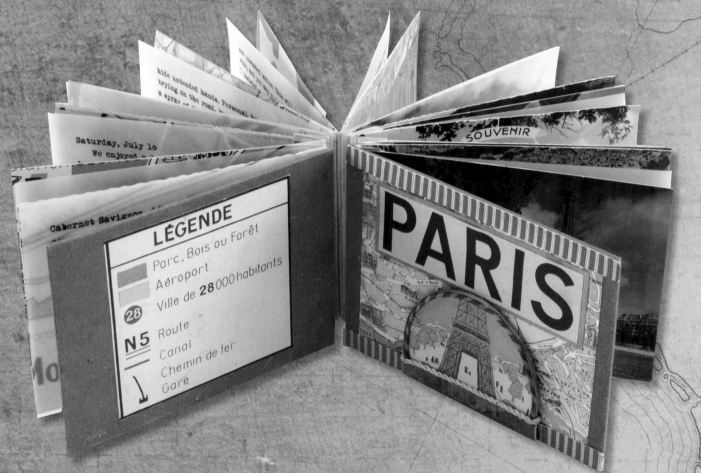

Postcard Journal

Every time I go on a trip, I come home with a shopping bag full of postcards, maps, brochures and ephemera that I intend to use to commemorate the vacation. As you can imagine, my studio is full of such bags. My intentions are good, but often the bags sit there for a while. Now is the time to use those treasures!
Make a book of postcards and maps from a trip you took or hope to take. This is the perfect project for traveling, as you can journal on the postcards during the trip and bind them when you get home.

My Map Story

My grandparents went to Paris in 1953 and returned with maps and unwritten postcards. I decided to interview my mom about what she remembered from their trip, and then I wrote a journal in my grandmother's voice. Since my Nana was a professional writer and would have typed a journal on her Royal typewriter, I typed the journal on typing paper that actually belonged to her. It was hugely entertaining to channel my grandmother, who was quite a character.

> *Monday. The third day I set to shopping, as any sensible woman would in Paris. It was a gloriously sunny and successful day, at the end of which dear Glenn was laden with bags and I was actually beginning to feel civilized. Lunch along the Seine,* coq au vin, *and, of course, more* vin *than* coq, *merci beaucoup. A song popped into my head and stayed there, darn that Dinah Shore. "Gimme eastern trimmin' where women are women/ In high silk hose and peek-a-boo clothes/ And French perfume that rocks the room/ And I'm all yours in buttons and bows." Saw an actual bottle of Joy, at a mere $450 an ounce, the most expensive perfume in the world. That one actually would rock the room, avez-vous d'accord?*

This book is made with vintage postcards, which are smaller than today's postcards. Make your book to fit the largest of your postcards, and adjust the cover size and end sheets accordingly.

MATERIALS AND TOOLS

1—1½" × 4½" (4cm × 11.5cm) piece of cover weight paper

1—4¼" × 22" (11cm × 56cm) map

2—4" × 5¼" (10cm × 13cm) maps

2—4¼" × 6" (11cm × 15cm) pieces of book binder's board

2—5" × 7" (13cm × 18cm) pieces of decorative paper

15—4" × 5¼" (10cm × 13cm) vellum sheets

15— 4" × 5¼" (10cm × 13cm) vintage postcards with horizontal orientations

bone folder

double-sided tape

glue brush

ribbons

scissors

typewriter or typewriter font

various maps, brochures and other paper ephemera

white glue

Covering Boards

Glue cover board to center of cover paper.

Trim corners at 45 degrees, one thickness of cover board from edge.

Turn in sides A and B and glue.

Turn in sides C and D and glue.

Glue panel 1 to front cover board, lining up with back edge.

Glue panel 32 to front cover bard, lining up with back edge.

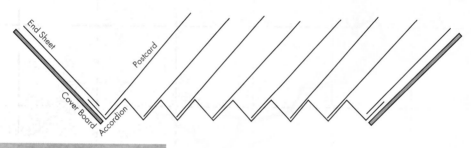

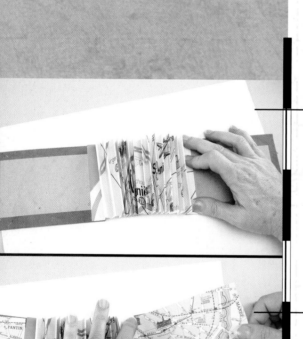

1

Cover the boards as you did in Steps 2 and 3 of the *Unfolding Maze of the Future* (see page 106). Fold the spine map into an accordion, using the illustration above as a guide. Glue the spine to the covers so the "mountain sides" (peaks) of the accordion are facing up, and attach the end panels to the covers, lining up the back edges.

2

Glue maps to the inside of each cover. Smooth out air bubbles with a bone folder.

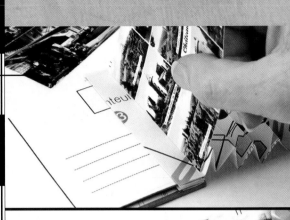

⋙ 3 ⋙

Glue postcards within the valleys of each of the accordion folds on the right (even numbered) sides, as per the illustration.

⋙ 4 ⋙

Decorate the backs of postcards with maps or other images as desired.

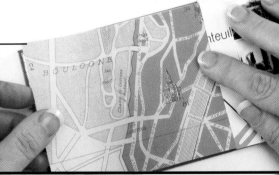

⋙ 5 ⋙

Use a typewriter or a typewriter font on your computer to add journaling onto 4" × 5¼" (10cm × 13cm) sheets of vellum. Place a piece of double-sided tape into the bottom of the accordion fold of the spine. Burnish the tape down with a bone folder before removing the top layer.

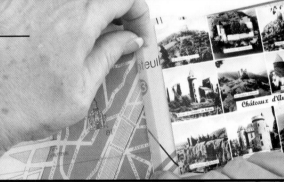

⋙ 6 ⋙

Set a vellum page onto the tape. Repeat in each fold on the left side.

⋙ 7 ⋙

Decorate the front cover by gluing a map, a 1½" × 4½" (4cm × 11.5cm) piece of cover weight paper for the title block, ribbons and other decorative items. I used the lid from a container of brie as an extra element. If you collect items while traveling, use something from your collection for the cover.

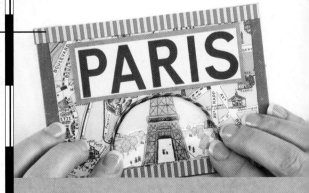

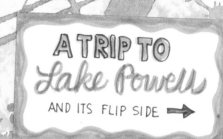

A TRIP TO
Lake Powell

AND ITS FLIP SIDE →

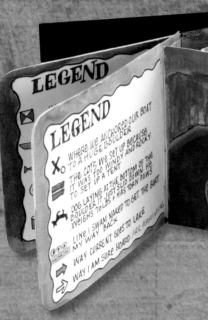

LEGEND

X WHERE WE ANCHORED OUR BOAT TO A HUGE BOULDER

THE COTS WE SET UP BECAUSE IT WAS TOO WINDY AND ROCKY TO SET UP A TENT

DOG LAYING AT THE BOTTOM OF THE BOULDER IT JUST SLID DOWN. HE WEIGHS 70 LBS + HAS TORN PAWS

LINE I SWAM NAKED TO GET THE BOAT MY WAY BACK

WAY CURRENT GOES TO LAKE · SEE ARROWS

→ WAY I AM SURE HOARD

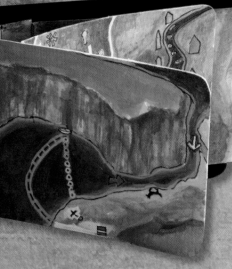

THE MORAL OF THIS *Story*

NEVER GO CAMPING AFTER MONTHS OF WORKING TOO MANY HOURS · GO TO SPA OR SOME PLACE MOTHER NATURE CAN'T FIND YOU!

Flipping Trip

Think of a trip with a flip side to it. The nature of the structure requires a funny story, because flipping is never sad. You may have to dig deep to find the amusing side of a really bad vacation or other event. Is there a trip you took that transformed from good to bad, or the other way around? Here's your chance to chronicle it.

My Map Story

A few years ago, my husband and I went camping on a large lake with our two dogs. After months of working many hours of overtime, we were jittery with anticipation. We rented a small motorboat at the marina and were asked if we wanted insurance. *Why would we need that?* we thought. *What could possibly happen?*

What could happen, did. The wind came up and the water level rose, forcing us to camp on rocks. Both the boat and our big black dog vanished in the night. We ended up sitting on a the rocky shoreline, in 118-degree heat, with no boat or supplies and only one dog, with a wild wind whipping at us, wondering what the insurance might have covered. It is a very funny story now, but at the time . . . well, that was a different story. In the end, we found a dog-friendly bed and breakfast in town a few hours away, on a river. Dogs were everywhere, lounging on rocks, sitting in the water, some looking like their owners. It was a funny-movie ending to our battle with Mother Nature.

MATERIALS AND TOOLS

1—1¼" × 6" (3.5cm × 15cm) piece of cover weight paper (tab stop)

1—3" × 11" (8cm × 28cm) piece of cover weight, cut grain short (pull tab base)

1—3⅝" × 23" (9.5cm × 58.5cm) piece of cover weight paper (Piece 2 of book cover)

1—3⅝" × 6⅝" (9.5cm × 17cm) piece of mat board

1—6⅝" × 7¼" (17cm × 18.5cm) piece of cover weight paper (Piece 1 of book cover)

4—3¼" × 3¾" (8.5cm × 9.5cm) pieces of heavy text weight paper, cut grain short

12" (30.5cm) of ribbon

black fine-tip waterproof marker

craft knife

cutting mat

paintbrushes

paper hole punch

pencil

straightedge

watercolors or gouache paints

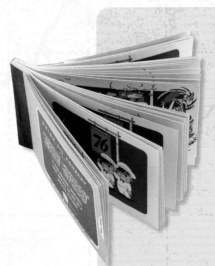

Inspired by . . .
Flip Books

A flip book, or flick book, has a series of pages that appear, when flipped quickly, to animate a story with the illusion of motion. The first book of this type was invented in 1868 and was called a kineograph.

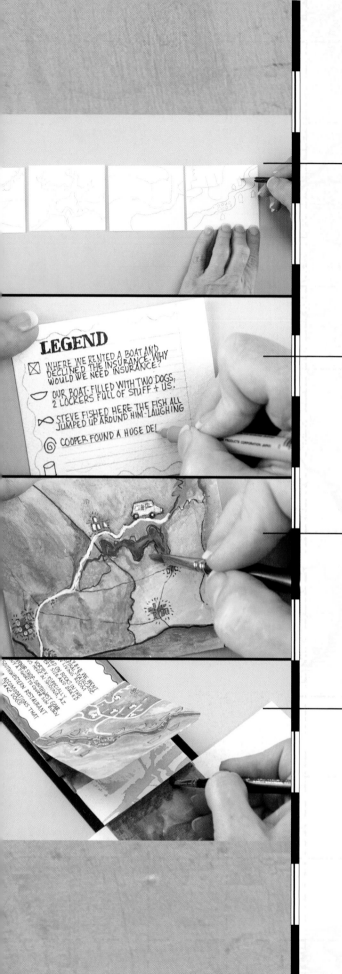

>»« *1* »«<

Sketch four maps to represent the different stages of your story onto four 3¼" × 3¾" (5cm × 5cm) pieces of heavy text weight paper.

>»« *2* »«<

Draw a legend to correspond with each map on the back of each page. Leave ¾" (2cm) on the right side blank. This is where the page will be glued into the book.

>»« *3* »«<

Paint the maps using watercolors or gouache paints. Color in the legends.

>»« *4* »«<

Use the illustration on the facing page to assemble the flipping book. Pull the last page out as far as it can go. Paint around the paper tab that the last page is inserted through. Add a moral of the story in this area.

Assembly Instructions

A) Score the pull tab base as shown. Fold each score, lining up the upper and lower edges. Fold the ½" (1.3cm) end under and secure it with glue.

½" (1.3CM) | 6" (15CM) | ⅝" (1.6CM) | ⅝" (1.6CM) | ⅝" (1.6CM) | ⅝" (1.6CM) | 2" (5CM)

B) Apply glue to the last ⅝" (1.6cm) section of the pull tab base. Glue it to line up with the center line on the tab stop. Center it vertically.

C) Fold the pull tab base at X. Fold the flaps of the tab stop around the pull tab base. Apply glue to the flaps.

D) Turn the unit over and center it on the base piece.

E) Apply glue to the first panel and place the first page on it. Line up the left side of the page with the fold. Center it vertically.

F) Repeat Step E with the remaining pages. Periodically check to see they are not glued together by pulling the tab.

G) Punch a hole in the center of the folded edge. Pull a ribbon through, even it up and knot it.

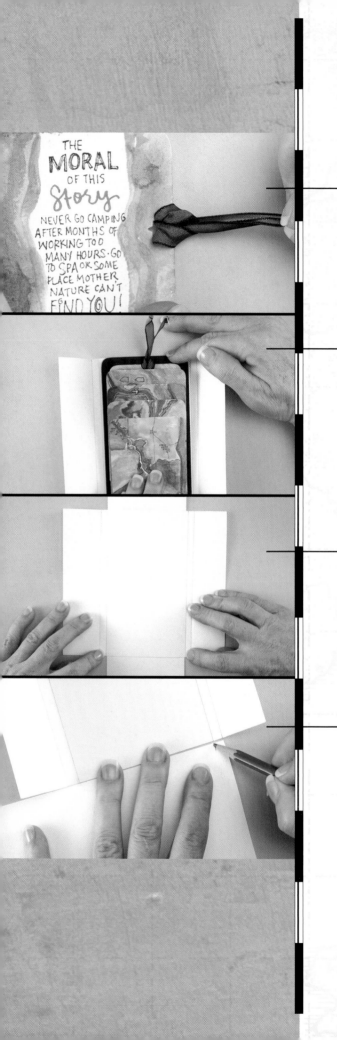

5

Punch a hole on the right side of the tab, through the part that is folded over. Attach a ribbon with a lark's head knot.

6

The cover of the book is made of two pieces of cover weight paper. Piece 1 measures 6⅝" × 7¼" (17cm × 18.5cm). Lay the book in the center as shown and mark both sides. Mark ¼" (6mm) to the outside of the first marks on both sides. Score both lines using a craft knife and a straightedge.

7

Piece 2 measures 3⅝" × 23" (9.5cm × 58.8cm).

8

Place Piece 2 perpendicular to Piece 1. Use the lines on Piece 1 to mark the spine-width distance on one short end of Piece 2 as shown. Repeat on the other side of the strip.

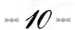

Fold the left side of Piece 2 over and line up the edge with the mark on the right side. Unfold. Fold the right side over and line up the edge with the mark on the left. Unfold. You should have two folds in the center of Piece 2, creating a spine.

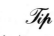

Fold in the flaps of Piece 1 and set it against the spine of Piece 2. Fold one side of Piece 2 up and into Piece 1 as shown. Crease and secure. Repeat for the other side. Slip the flip book into the cover with the ribbon sticking out.

Tip

Use printed maps for this project and paint over them.

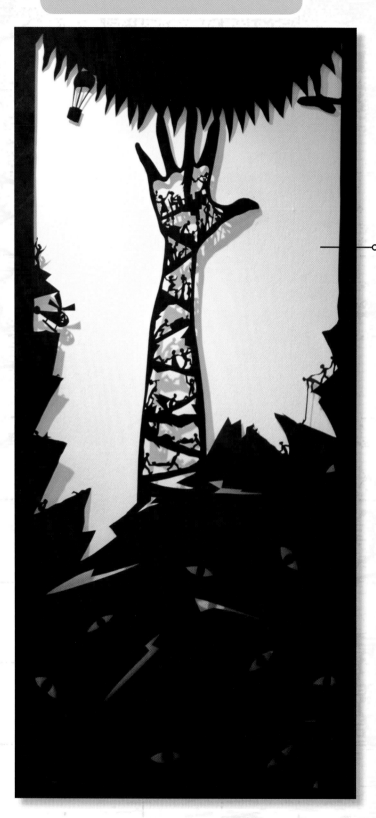

Ayiti Cheri

Béatrice Coron

Fundraiser at Tabla Rasa Gallery in Brooklyn for Haiti after the January 12, 2010 earthquake. An emotional map of Haiti after the disaster.

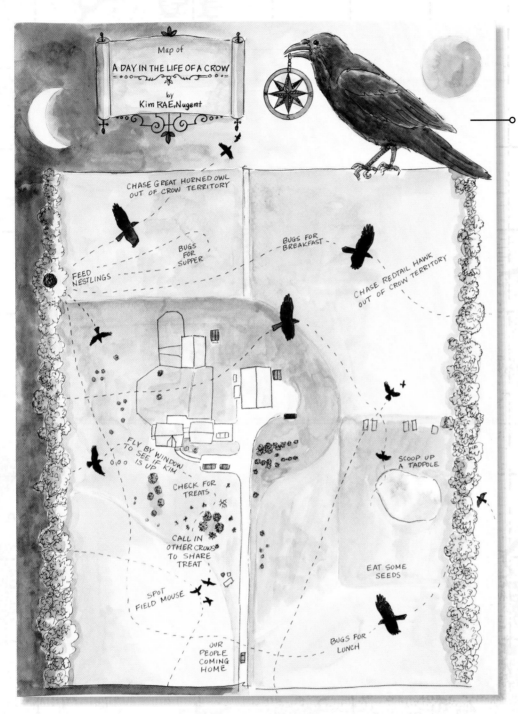

Map of
A DAY IN THE LIFE OF A CROW
by
Kim RAE, Nugent

CHASE GREAT HORNED OWL OUT OF CROW TERRITORY

BUGS FOR SUPPER

BUGS FOR BREAKFAST

CHASE REDTAIL HAWK OUT OF CROW TERRITORY

FEED NESTLINGS

FLY BY WINDOW TO SEE IF KIM IS UP

CHECK FOR TREATS

CALL IN OTHER CROWS TO SHARE TREAT

SPOT FIELD MOUSE

OUR PEOPLE COMING HOME

SCOOP UP A TADPOLE

EAT SOME SEEDS

BUGS FOR LUNCH

A Day in the Life of a Crow

Kim Rae Nugent

Crows are one of my totem animals. I am fascinated by their antics. I started with a scale drawing of a portion of our property. The time from dawn to dusk is symbolically represented by the sun and moon. Some of the events diagrammed I have actually witnessed, such as a crow chasing a Red-tailed Hawk off our property. Other events are typical crow behavior. There is a car mapped to represent each member of my family.

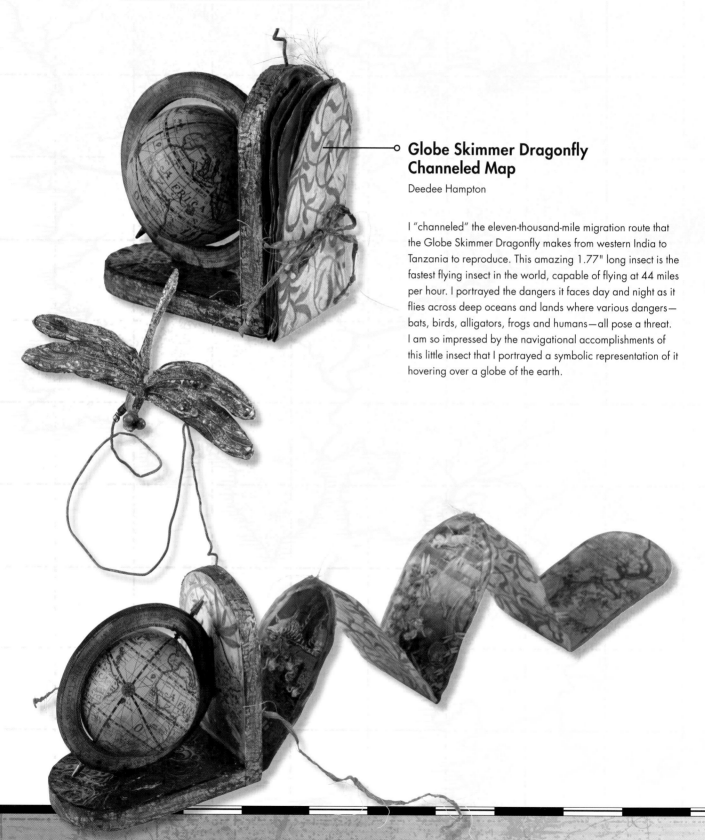

Globe Skimmer Dragonfly Channeled Map

Deedee Hampton

I "channeled" the eleven-thousand-mile migration route that the Globe Skimmer Dragonfly makes from western India to Tanzania to reproduce. This amazing 1.77" long insect is the fastest flying insect in the world, capable of flying at 44 miles per hour. I portrayed the dangers it faces day and night as it flies across deep oceans and lands where various dangers— bats, birds, alligators, frogs and humans—all pose a threat. I am so impressed by the navigational accomplishments of this little insect that I portrayed a symbolic representation of it hovering over a globe of the earth.

Living Below Sea Level

Gwen Diehn

These two images are pages from an artists' book that I made in response to Hurricane Katrina. I was born and raised in New Orleans and remember well the strange knowledge that we lived three feet below sea level. This situation was evident in many ways: the fact that we could see ships and barges riding along at the level of roof tops, crayfish holes in our backyards, the ever-present threat of flooding, etc. I chose map imagery for many of the pages in the book because of the geographical nature of this strange situation.

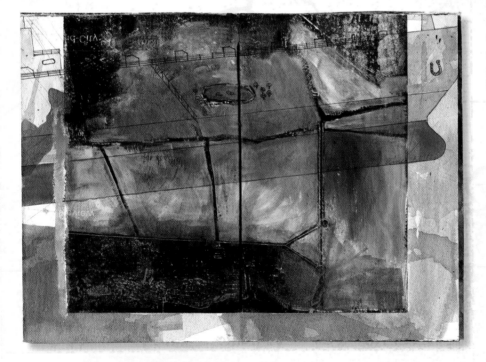

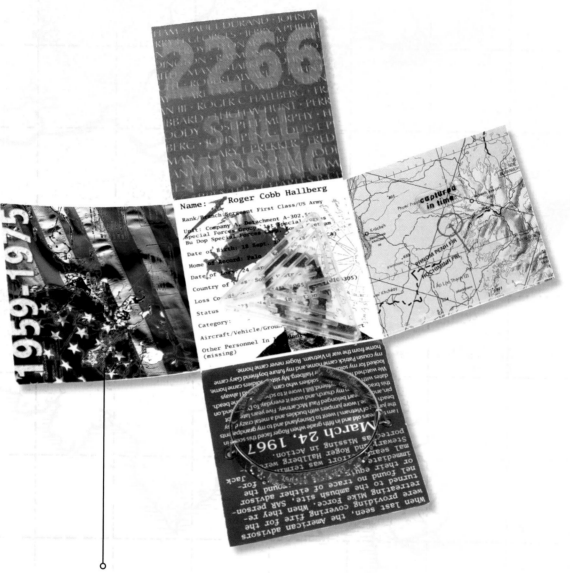

POW Cartographic Reliquary

Jill K. Berry

This is a tribute to Roger Cobb Hallberg, whose name was on the POW bracelet I wore as a teenager. This is meant to be a temple to contain his memory, since he is one of many service people unaccounted for in the Vietnam conflict.

Inside are five panels. The United States flag is overlaid with a map of Vietnam on the first. The second is Roger's name on the wall in D.C. The third is a map of approximately where he went missing. The fourth is my bracelet with his name on it, and two stories. The top story is the military account of Roger's last known day. The bottom story is what I was likely doing that day, when Roger disappeared protecting his men. In the center is his military biographical information overlaid with a plastic maze. The helicopter is like the one that came to rescue him, and did not find him.

Book Of Souls
"Arnold Doesn't Play Here Anymore"

Judy Wilkenfeld

The forced dispersal, throughout the world, of my people and my family is an issue that weighs heavily on my heart. Whilst I was making this piece, I pondered on the dozens of countries my family now find themselves in. I chose this story from amongst many, as mapping it was important for remembrance.

My grandfather's brother Kalman, his wife Berta and their son Arnold lived in Kiel, Germany during World War II. As a child, Arnold and his cousin Judith played at the park; he lived only a few houses away from her. They spent most days together, but before long they were separated. Judith's journey found her safe in what was then Palestine, but Arnold and his family could not get their papers in time. Their fate was left in the hands of the Nazis, who eventually slaughtered them all.

For the *Book of Souls*, I cut and sewed leather soles together to form the covers of an accordion book. The "signatures" within the book are made from hand-soldered shoe forms that I created to house photos of Arnold's family. Railroad and city maps overlay the images, which were then filled with resin to create the layers of their story. I hand-engraved each of the soldered soles on the left side of the book with the tragic fate that they met. The right side of the book was engraved with information from Kalman's tombstone. Berta and Arnold have no graves. Those killed in the Holocaust do not have marked graves.

Antique photo album covers were used to create a book form, the spine of which reveals the handwritten testimony of Arnold's grandmother of what happened to her family. The spine was layered with yellow paper, the color being symbolic of the yellow star they had to wear to identify themselves as Jews at that time.

A pair of children's shoes, covered in the map of Kiel, sits atop a resined map, hiding the accordion book below. Pertinent places on the map were placed on specific areas of the shoe. For example, Adolphstrasse was positioned on the tongue, an allusion to the incapacity of children to speak for themselves against the tyranny of Adolph Hitler. Maps feature heavily in the piece, identifying their journey from Kiel back to their home town of Zolynia, Poland, and the train routes they took from the ghetto to the places where they were finally killed.

Arnold loved playing in the park with his cousins. Together with his mother, he met his fate with thousands of other mothers and children, gunned down together in the forest not far from their ancestral home.

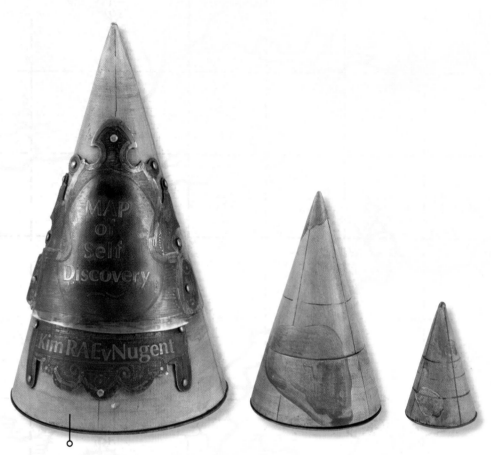

Map of Self Discovery

Kim Rae Nugent

The point of departure for this journey began with three wooden nesting cones. I was inspired to begin creating after looking up the meaning of the word *cone*, which yielded the word *apex*. Thus began the *Map of Self Discovery*.

Each cone represents a stage of self discovery. The first stage is the "childish self." This stage has three components: learn, play and grow. The word *childish* is often associated with the negative connotation of being immature. However, it is important to retain the qualities of being a child throughout one's life. The second stage is the "parental self" and is also made of three components: teach, nurture and discipline. The third stage of self discovery is the "spiritual self." It is made up of these components: relationship with self; relationship with others and relationship with environment. The shortest distance to the apex or summit of our being is our relationship with a higher power.

These qualities encompass one another and together form a trinity of self discovery. Within the parental self is the childish self. Within the spiritual self are the parental and childish selves. The color blue represents water, while brown represents land. The black inside the cone represents air and other forces we cannot see. On the bottom of each cone is etched the directional symbol of a compass rose. The designs go from simplistic to more complex and help to further define the level of each self.

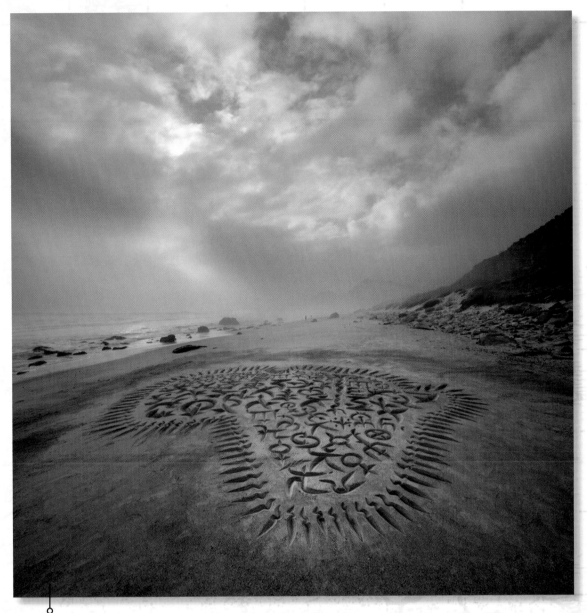

African Calligrapher, Me

Andrew van der Merwe

This is a self-portrait, the quill-wielding, running figure at the Southern tip of Africa being the way I see myself in happier moments. All those other fantastical, interlocking and interconnected letters and symbols—many of which come from African writing systems—represent the way I, as a white South African, see Africa with all it's incredible diversity and liveliness, but especially all those indigenous languages whose sounds and forms I so love but do not understand.

This piece was carved at Witsands Beach near Misty Cliffs, Cape Town, on the afternoon of Sunday, January 16, 2011. I nearly lost this piece to bleakness and rain before I could finish it but was lucky enough to have that patch of blue move overhead briefly. It left me with a perfectly apt picture. A happy, sunny sky would have been totally wrong. Under the current political climate, it's more truthful to depict Africa as cloudy with promise.

Acknowledgments

LEGEND

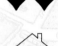 1. Steve, my husband, who has been traveling this road with me for many years, gave me enthusiastic support to do this, and with whom I have shared so many wonderful adventures.

 2. Sydney and Sam, my fascinating darlings, who did not like having a mother who was writing a book, but are very proud to say their mother is an author.

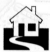 3. Joanna, my mother, who taught me that having curiosity is the key to a rich life, and supported every step of my journey.

 4. My sister Linden, who was brave enough to edit and improve my words.

 5. Mildred Masterson McNeilly, my grandmother, who was a writer who believed in perseverance and practice. She often said to me "John is a better writer than Mac, but Mac writes."

 6. My aunts, Mary and Ann, who always believed in me and said so.

 7. My friends and family members who loaned me supplies, drove my kids around, and supported this effort in essential ways.

 8. Rachel, my editor, who is so organized, precise and kind.

 9. Kelly, the designer, for her talent and perseverance.

 10. Christine, the photographer, who makes it all look so easy.

 11. Tonia, who honed in on this passion of mine and made this journey possible.

 12. Kim, Gwen, Carla, Andrew, Gil, Orly, Paul, Giovanni, Mitsuko, Deedee, Béatrice, Aimee, Jane, Hillary, Heidi, Judy Wilkenfeld and Judy Wise, the talented contributing arty cartographers, for saying "yes."

About the Author

Jill Berry is a mixed-media artist, teacher, mom and explorer in the foothills of the Rocky Mountains who makes lots of books and other story-telling structures. After completing a degree in design, she spent a year doing graduate studies in Italy, where she learned to see a bigger picture of both art and the world in general. Her work often involves maps, symbols, houses, housewives and the mystique of charisma.

Her paintings and artists' books have been shown in national invitational and juried shows and can be found in public and private collections across the United States. She has taught at three universities in Colorado and various other institutions nationally. She loves to explore the world, and considers curiosity to be her greatest asset. She lives in Superior, Colorado with her boy, her girl, her musician husband and a large zen poodle.

About the Contributors

Gil Avineri was born in 1981 to a psychic Colombian whistle blower and a modest Israeli electrician. He was raised in L.A., Houston, and Miami. He has been a New Yorker since 2006 and a taxi driver for almost as long. He has practiced collage art journaling on life's every detail (work, study, play and pray) since the age of 15. Every word, illustration, thought and action he makes is for the sole purpose of revealing light by tweaking the urge to receive. He is obsessed with geography, anthropology, linguistics, sustainable lifestyles, subsistence farming, urban bicycling and so much more. Follow his blog: taxicabnyc. blogspot.com.

As a young adult in Israel, **Orly Avineri** studied Fine Art in an artists' village nestled at the foot of Mount Carmel overlooking the Mediterranean Sea, and later, Graphic Design at the University of Arts in the Netherlands, in the contemporary yet history-drenched city of Utrecht. Now living by the shore of Southern California with her family, Orly expresses the magnificence of the landscapes that shaped her and the visual languages she has acquired along the way.

Looking back a lifetime, **Hillary Barnes** realizes she has always been creative and recorded things around her. New Zealand has a culture of improvisation, using whatever is at hand, which is necessary because supplies would take many months to order and arrive from overseas. Hillary is currently fascinated with lines and exploring printmaking.

Mitsuko Baum's artists' book and box making started in 2002, when she discovered the world of book arts, and it grew organically from there. She is particularly interested in box construction and paper engineering. Something about a box appeals to her; containing, intimacy, coziness, revealing, the thrill of opening a box. She also likes to add an element of nice surprise to her work, such as movable parts, unexpected contents, something extra that makes you smile. Please visit her website at www.mitsukobaum.com to open my boxes.

Giovanni Cera was born in 1951 in Pulsano, Italy. He graduated with a degree in architecture in 1977 and has worked as a state architect since 1980. He received two awards in a competition on building techniques and has illustrated books on construction science and techniques. As a botanical artist, he took part in the international exhibitions Kunstart 2008 and Botalia 2010. He is an illustrator, botanical artist and "tired architect".

Born in France, **Béatrice Coron** lived in Egypt, Mexico and China before moving to New York. Coron tells stories in illustrations, bookarts, fine arts and public art. She adapts her papercut designs in metal, stone and glass. Coron's papercuttings were shown at Slash at the Museum of Arts & Design and she spoke about her creative process at TED 2011. To catch her all in one place, visit her website at www.beatricecoron.com.

About the Contributors

Gwen Diehn's prints, drawings, and artists' books have been exhibited internationally and are in numerous collections, including that of the National Museum of Women in the Arts. She is the author of several books, including *Simple Printmaking*, *The Decorated Page*, and *Real Life Journals*. Her main artistic interests are in relief printmaking, drawing, mixed-media artists' books and visual journaling. You can see more of her work at her blog, http://real-life-journals.blogspot.com.

Aimee Myers Dolich's drawings and words are all about trying to capture bits of the everyday in some small way. She thrives on documenting moments, conversations, observations and experiences that seem ordinary and mundane, for they are the things that, when examined more closely, are what make life mysterious and fascinating to her. For more, please visit http://artsyville.blogspot.com.

Deedee Hampton seeks out amulets and oddities, saints and sinners, and miracles and magic to use in her narrative assemblages. She loves to explore the big questions that embrace mythology, religion and philosophy in her artwork. Visit her blog at http://deedeehampton.wordpress.com, which explores the creative process with lots of fun pictures and interesting tidbits.

Paul Johnson has an international reputation for his pioneering work in developing literacy through the book arts and as a book artist. He is the author of over fifteen titles including *A Book of One's Own* and *Literacy Through the Book Arts*. His unique pop-up books are in most of the major collections in the USA including the Cooper-Hewitt Museum in New York and the Library of Congress, Washington DC.

Jane LaFazio, a full-time artist since 1998, truly believes she is living the life she was meant to live! She has cultivated a wide range of skills as a painter, mixed-media artist, quilt artist and art teacher. She teaches workshops online and at art retreats internationally. Jane's artwork has been featured in *Cloth, Paper, Scissors* and *Quilting Arts* magazines many times, and in numerous books. She can be found at http://plainjanestudio.com and http://janeville.blogspot.com

Heidi LaMoreaux is a formally trained geographer with a Ph.D. in physical geography from the University of Georgia. She brings this geographic background to her academic and artistic endeavors, and has created a class in the Hutchins School of Liberal Studies at Sonoma State University titled "Personal Geographies". In this class students explore their personal history using maps, personal reference slides, personal compass roses and creative nonfiction writing. For more information about how Heidi merges science, geography, writing and art, visit www.innergeographies.com.

Kim Rae Nugent is a mixed-media artist from Fredonia, Wisconsin. She has spent her life cultivating her skills in collage, oil painting, sculpture, sewing, art journaling and assemblage, often cross-pollinating mediums for unique and exciting projects. Her love of nature and animals is often reflected in her art. Kim's art work has been featured in numerous publications including her book *Interactive Art Workshop: Set Your Mixed Media in Motion*. www.kimraenugent.blogspot.com

Carla Sonheim is a painter, illustrator and creativity workshop instructor known for her fun and innovative projects and techniques designed to help adult students recover a more spontaneous, playful approach to creating. She is the author of *Drawing Lab for Mixed Media Artists: 52 Creative Exercises to Make Drawing Fun* and creator of "The Art of Silliness," a popular online drawing course. She lives in Seattle, where she shares space with her photographer husband, a game-playing teenager and her laptop. www.carlasonheim.com; www.carlasonheim.wordpress.com

Andrew van der Merwe is a professional calligrapher with about twenty years of experience. While most of his work consists of commercial lettering for other designers and agencies, he also does traditional, illuminated address work and writing for certificates and envelopes. Lately, he also calls himself a beach calligrapher. Beach calligraphy is a new, unique art form. He carves the letters directly into the sand using instruments and techniques he has developed.
 Andrew is a keen surfer, philosopher and father.

Judy Wilkenfeld is a mixed-media and book artist from Sydney, Australia. Her mixed-media art works, Visual Anthologies, tell the story of a life or lives, past or present. Judy's pieces portray the good and the bad, happy or sad elements of life, and sometimes, the complex subject matters of the persecution of races, religions and minority groups which are tackled with the utmost of sensitivity. To communicate the message of tolerance and understanding is imperative in her pieces. Judy has been published in numerous books and art magazines, as well as in he three leading paper arts magazines in Australia and teaches her techniques throughout the world.

Judy Wise is an Oregon painter, writer and teacher whose work has been published over several decades in books and periodicals, on greeting cards, textiles, educational materials, calendars and in the gift industry. She is a lifelong keeper of journals and a passionate lover of all things artful. She has a popular art blog at http://judywise.blogspot.com and has co-written a book with Stephanie Lee entitled *Plaster Studio: Mixed Media Techniques for Painting, Casting and Sculpting*.

Personal Geographies. Copyright © 2011 by Jill K. Berry. Manufactured in U.S.A. All rights reserved. No part of this book may be reproduced in any form or by any electronic or mechanical means including information storage and retrieval systems without permission in writing from the publisher, except by a reviewer who may quote brief passages in a review. Published by North Light Books, an imprint of F+W Media, Inc., 10150 Carver Road, Blue Ash, Ohio, 45242. (800) 289-0963. First Edition.

www.fwmedia.com

16 15 14 13 12 5 4 3 2

DISTRIBUTED IN CANADA BY FRASER DIRECT
100 Armstrong Avenue
Georgetown, ON, Canada L7G 5S4
Tel: (905) 877-4411

DISTRIBUTED IN THE U.K. AND EUROPE BY F&W MEDIA INTERNATIONAL
Brunel House, Newton Abbot, Devon, TQ12 4PU, England
Tel: (+44) 1626 323200, Fax: (+44) 1626 323319
Email: enquiries@fwmedia.com

DISTRIBUTED IN AUSTRALIA BY CAPRICORN LINK
P.O. Box 704, S. Windsor NSW, 2756 Australia
Tel: (02) 4577-3555

SRN: Z9239
ISBN-13: 978-1-4403-0856-7

Editor: **Rachel Scheller**
Designer: **Kelly O'Dell**
Production Coordinator: **Greg Nock**
Photographer: **Christine Polomsky**

Metric Conversion Chart

To convert	to	multiply by
Inches	Centimeters	2.54
Centimeters	Inches	0.4
Feet	Centimeters	30.5
Centimeters	Feet	0.03
Yards	Meters	0.9
Meters	Yards	1.1

Resources

Specialty Items

K & S Engineering
www.ksmetals.com
copper foil

Creative Papers Online
http://handmade-paper.us
handmade papers, leather and unryu

Dreaming in Color
www.dreamingcolor.com
Twinkling H20s iridescent watercolors

The Map Shop
www.mapshop.com
map pins, flags and pennants

PanPastel
http://panpastel.com
artist painting pastels

www.jetpens.com
Pens, pencils of all types and black erasers

Jacquard
www.jacquardproducts.com
Piñata Colors alcohol inks

Cartographic Clip Art

There are lots of books of cartographic clip art available. Check with your local bookstore.

Research Sites

The History of Sea Monsters
www.strangescience.net

Florida Center for Instructional Technology Clip Art for Education
http://etc.usf.edu/clipart

The Library of Congress Map Collection
http://memory.loc.gov

Reading List

Spade and Archer's 50 Maps of L.A. by Spade & Archer (H.M. Gousha Co)

Pictorial Maps: History, Design, Ideas, Sources by Nigel Holmes (Watson-Guptill)

The Island of Lost Maps: A True Story of Cartographic Crime by Miles Harvey (Broadway)

Maps of the Imagination: The Writer as Cartographer by Peter Turchi (Trinity University Press)

You Are Here: Personal Geographies and Other Maps of the Imagination by Katharine Harmon (Princeton Architectural Press)

The Map as Art: Contemporary Artists Explore Cartography by Katharine Harmon (Princeton Architectural Press)

Strange Maps: An Atlas of Cartographic Curiosities by Frank Jacobs (Studio)

Credits

page 27: Used by permission of Art2Be
ww.art2bebodymaps.com

page 31: Reprinted from Santa Cruz County Place Names; a geographical dictionary by Donald Thomas Clark, Kestrel Press 2008, with permission of the publisher, kestrel-press.com.

page 78: Illustration used with permission of the jomoratrust.com.

Index

abstract map, 8
adhesives, 15
Art2Be, 27
artistic journey map, 64–69
Avineri, Gil, 86, 139
Avineri, Orly, 48, 87, 139

Barnes, Hillary, 85, 95, 139
Baum, Mitsuko, 49, 94, 139
board game map, 8
boards, covering, 122
body maps, 26–29
body template, 29
books, and endpaper maps, 99

cartographic reliquary, 110–115, 134–135
cartophile, 4
cartouche, 10, 12
Cera, Giovanni, 50, 139
channeled maps, 98–103, 132
cheiromancy chart, 31
clip art, use of, 12–13, 141
collaborative map, 76–81
commemorative map, 120–123
compass rose, 10, 12
cordiforms (heart-shaped maps), 39
Coron, Béatrice, 119, 130, 139
creatures, on maps, 10

design of
 cartouche, 12
 compass rose, 12
Diehn, Gwen, 63, 81, 133, 140
Dolich, Amy Myers, 90, 109, 140

endpaper maps, 99
experiences, mapping of, 56–89

fictional maps, 98–103
flip book, 125
flipping map, 124–129
found object map, 8
future maps, 104–109

Hampton, Deedee, 47, 55, 93, 132, 140
hand maps, 30–37, 53–54
hand maps, carved copper, 34–36
head maps, 18–25
head template, 21
heart map, 39–43
heart map, computer, 42–43

Inuit coastal map, 9

Johnson, Paul, 54, 140

kineograph, 125

LaFazio, Jane, 91, 140
LaMoreaux, Heidi, 37, 51, 140
large-scale map, described, 11
legend, 10
longitude and latitude, 10

map key, 10
mapmaking supplies, 14–15
maze map, 104–109
metric conversion chart, 143
Mora, Joseph Jacinto, 78

narrative map, 82–95
neatlines, 10
 in projects, 32, 43, 60, 101, 118
Neurath, Otto, 72
Nugent, Kim Rae, 41, 52, 131, 136, 140

Ogilby, John, 66
Ortelius, Abraham, 100

palmistry, 31
pantins, 45
paths, on maps, 10
phrenology chart, 19
political map, 9
pop-up memory map, 59–63
 folding directions, 62

postcard journal, 120–123
prosaic map, 9

reflexology, 31

scale, on maps, 11
sea monsters, 10, 100
self, mapping of, 16–51
self-portrait, articulated, 44–56
small-scale map, described, 11
Sonheim, Carla, 53, 140
story-telling map, 82–95
street maps, 22–25
strip map, 65–66
supplies, 14–15, 141

templates
 body, 29
 box top, 115
 compass rose, 12
 head, 21
Terra Incognita, 11
territory, unknown, 11
tools
 coloring, 15
 drawing, 14
 metal-working, 15
 miscellaneous, 15
topography, 11
tradition and memory maps, 59–63
trap streets, 11
TripTik, 66

utopia, 117
Utopian topography map, 116–119

van der Merwe, Andrew, 137, 140
vehicles, voyaging, 11
vintage postcards, 121

Wilkenfeld, Judy, 135, 141
wind blowers, 11
wind rose, 10
Wise, Judy, 89, 141

Download texture techniques for your mixed-media maps

 In this **FREE** download, Jill K. Berry shows you how to make "geopapers"—textural backgrounds with a geographic look—that are perfect for use in collaged maps, borders, book covers and wraps. Use the materials you have on hand (ink, plastic wrap, tissue paper, stencils and sponges) to create unique backgrounds you can use in your artwork or journal. Download the PDF at:

www.CreateMixedMedia.com/Personal_Geographies_Bonus_Techniques

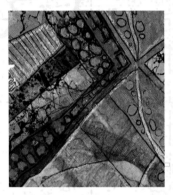 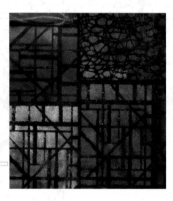

www.CreateMixedMedia.com

**The online community for
mixed-media artists**

**techniques
projects
e-books
artist profiles
book reviews**

For inspiration delivered to your inbox
and artists' giveaways, sign up for our
FREE e-mail newsletter.

Follow us on Twitter and Facebook!

 @cMixedMedia

 facebook.com/
CreateMixedMedia

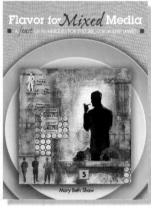

NORTH LIGHT BOOKS

Get your favorite
North Light Books at
www.ShopMixedMedia.com